IN THE BLINK
OF AN EYE
THE WORLD AS
YOU'VE NEVER SEEN IT

IN THE BLINK

OF AN EYE

THE WORLD AS
YOU'VE NEVER SEEN IT

JOHN BRACKENBURY

D&C
David and Charles

To Zena

A DAVID & CHARLES BOOK
Copyright © David & Charles Limited 2007

David & Charles is an F+W Publications Inc. company
4700 East Galbraith Road
Cincinnati, OH 45236

First published in the UK in 2007
First US paperback edition 2007

Text and illustrations copyright
© John Brackenbury

John Brackenbury has asserted his right to be identified as
author of this work in accordance with the Copyright, Designs
and Patents Act, 1988.

A catalogue record for this book is available from the
British Library.

ISBN-13: 978-0-7153-2650-3
ISBN-10: 0-7153-2650-3

Printed in China by R. R. Donnelly
for David & Charles
Brunel House, Newton Abbot, Devon

Commissioning Editor: Neil Baber
Editor: Emily Pitcher
Art Editor: Marieclare Mayne
Production Controller: Beverley Richardson

Visit our website at www.davidandcharles.co.uk

David & Charles books are available from all good bookshops;
alternatively you can contact our Orderline on 0870 9908222
or write to us at FREEPOST EX2 110, D&C Direct, Newton
Abbot, TQ12 4ZZ (no stamp required UK only); US customers
call 800-289-0963 and Canadian customers call 800-840-5220.

CONTENTS

INTRODUCTION

This book takes us on a short journey into familiar places. In fact we only occasionally need to set foot outside the door and hardly ever beyond the garden wall. This may sound very insular but I think you will be surprised by what you see. Quite often what we regard as the familiar is actually the unknown, because it is so easy to look straight past it. Perhaps even more so in a world full of busy people whose minds are set on fixed objectives. Nature goes about its business literally beneath our noses – not only the nature of the open field but also the nature inside our homes. Things are happening all around us, whether we notice them or not – nature is indifferent to our attention. However, if we make the extra effort needed to see these events, our lives will inevitably be richer for it. Small discoveries made on our own doorsteps may be just as rewarding as those made in faraway places.

So what are these things? The pictures tell the stories of reflections in raindrops, soap films forming rainbows, water rearing up into the shape of cylinders and umbrellas, or a pinch of turmeric powder exploding like a volcano. As the pictures here and overleaf show, coloured milk leaps up into strange momentary forms, flying insects try to dodge raindrops, and glass marbles become briefly suspended in space on a sheet of water.

There exists a microcosm of happenings just outside our range of vision or attention: they are too quick or too small to notice. Yet in their brief appearances we see echoes and reflections of far greater events happening on a more global, even galactic scale. Such is the reach of the laws of nature. The pattern in the curlicues rising as steam from a boiled egg is united by the laws of physics, to the shapes of hurricanes and perhaps even spiral galaxies. And in searching for colour and form in the soap bubbles

Freezing time enables us to open a window onto a strange new world: these bizarre articulated forms were produced by pulling a tethered coin rapidly out of a container of coloured milk.

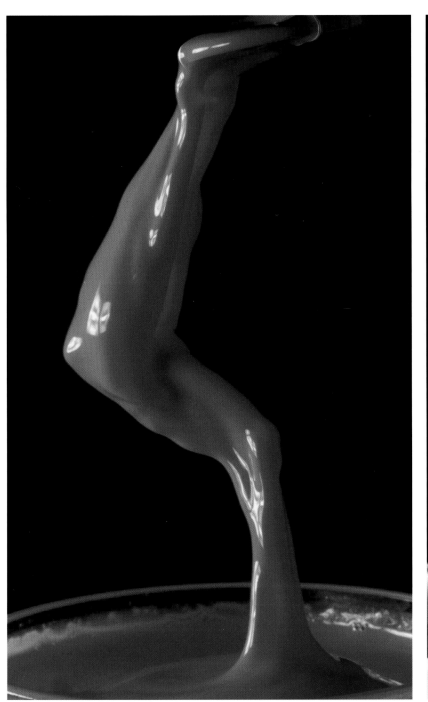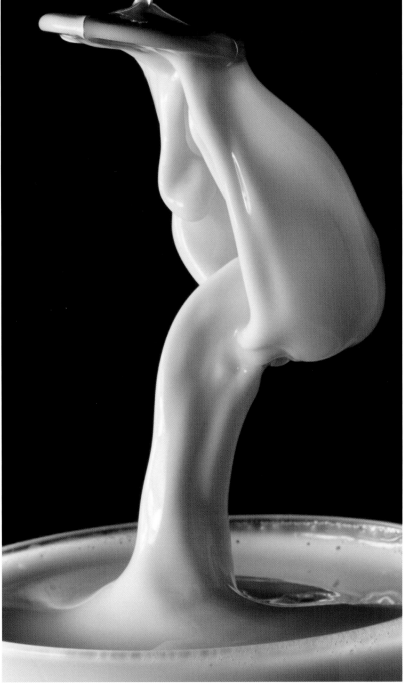

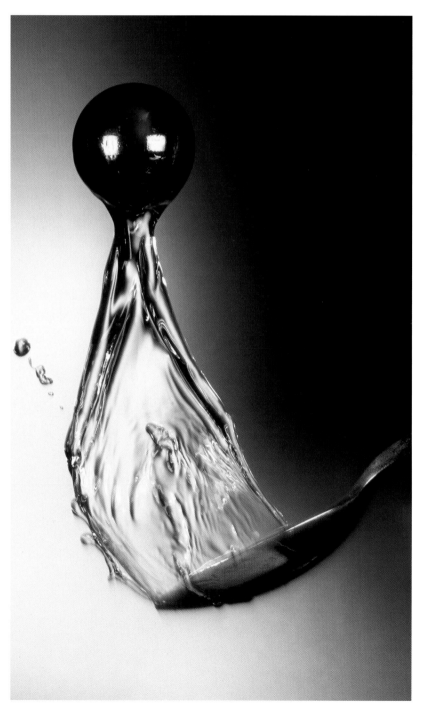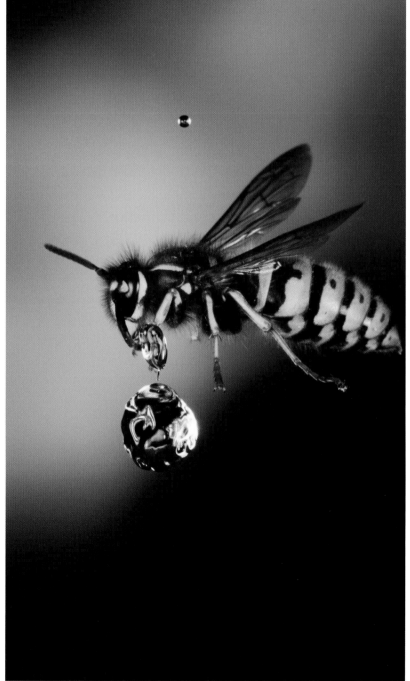

floating above the kitchen sink we find ourselves in the company of the great man himself: Isaac Newton. We may not share the prodigious intellect that allowed him to leap from rainbows to the fundamental nature of light but we can share his sense of wonder.

My own fascination with this close-up world began several years ago and the story unfolds between these pages more or less in the way it happened. Often the most difficult task was to visualize an event which I had not yet seen but which my intuition told me might be there. This is not necessarily the most effective scientific technique. But my reasons for doing it were not only the pursuit of knowledge. The incentive was 'show' as much as to 'know'.

In this era of digital photography and photo-manipulation, it is important to note that none of the images in this book have been manipulated or montaged in any way. I have attempted to create photographs that are compelling to look at and, to that end, have carefully controlled the set-up and lighting of every shot. Furthermore it was necessary to build some very specialist camera equipment to enable me to capture the events I wanted, but nevertheless what you see is not a concept realized by digital trickery, it is the true event in process as it was recorded on camera.

This book may or may not open minds but I hope that it will open eyes. My search involved designing aids for my own eyes in the form of high-speed photography, sating the scientific enquiries of my mind. The resulting glimpses of nature may ignite memories of chance observations you yourself have made, or if not, they may encourage your eyes to dwell a little longer.

The left picture shows what happens when a hand-held teaspoon, loaded with water, and a glass marble are lowered suddenly through the air. In that instant the marble remains suspended because its free fall under gravity is less than the downward speed of the spoon. On the right, a flying wasp takes a glancing blow from a water droplet.

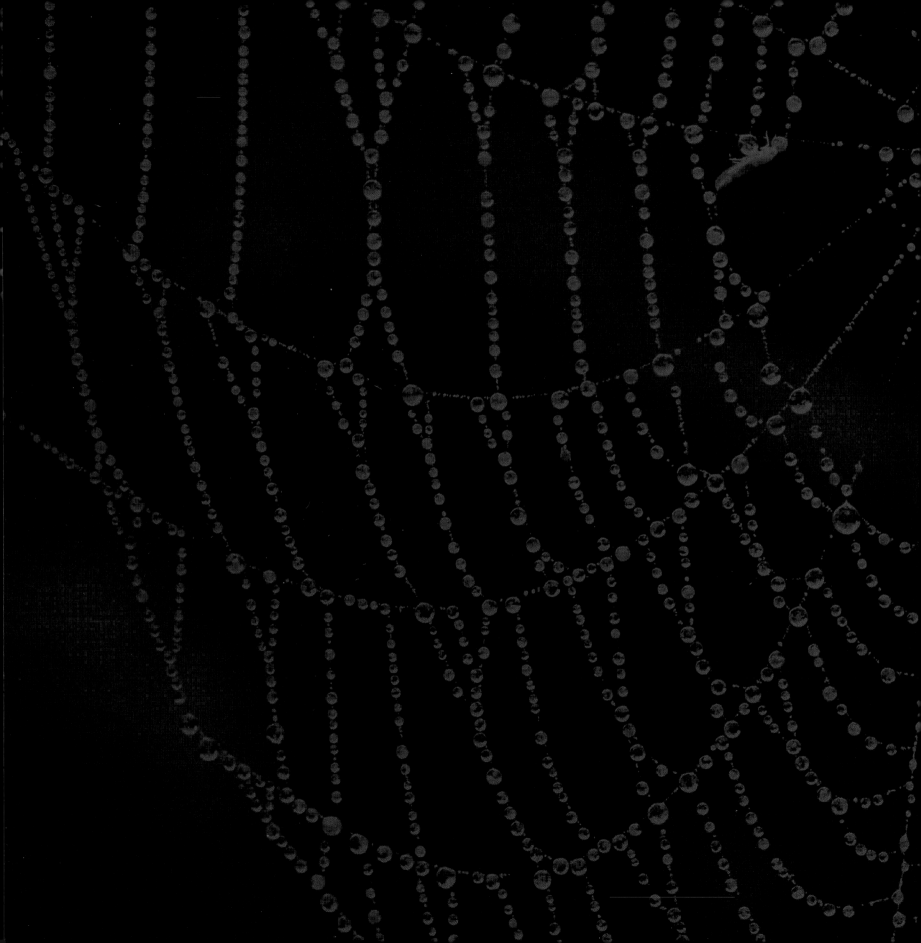

CHAPTER ONE
NATURE'S FRAGILE FORCES

When we encounter nature on an extremely small scale, at the level of raindrops, wriggling insects or whirlpools whipped up in teacups, we find astonishing order, harmony and form. These qualities are all the more impressive because of the diminutive size of the subjects in which they are displayed, and discovering them is like finding old coins in a ploughed field. Our lives are surrounded by almost invisible events triggered by armies of miniscule forces acting in benign and charming ways, and the images in this chapter illustrate just some of these events. It is easy to dismiss such phenomena merely as consequences of inexorable physical laws, but they can also be seen as a mirror of human experience on a lesser scale, or indeed a complement of the human sphere. To feel a sense of wonder at a natural event may be as important, sometimes more important, as attempting to understand how it came about.

Air is one of the few things we cannot see, yet we depend on it for our existence. Occasionally it bursts violently into our lives in the form of a tornado, or a spine-jolting bout of turbulence outside the jet aircraft on which we are travelling. The mechanical behaviour of air is influenced by its weight and its viscosity, both of which must be taken into account by designers of aircraft, space rockets, missiles and fast cars. Applying its forces to a very light material, such as turmeric powder, shows its potential power, albeit in a small scale.

Although invisible, air has weight. Therefore a puff of air applies a small force to anything in its path. In these photographs the blown material is a small mound of turmeric powder mounted either on a finger-nail [01] or a glass dome [02]. Seen in close-up the effect created is like a galactic spray or an erupting volcano.

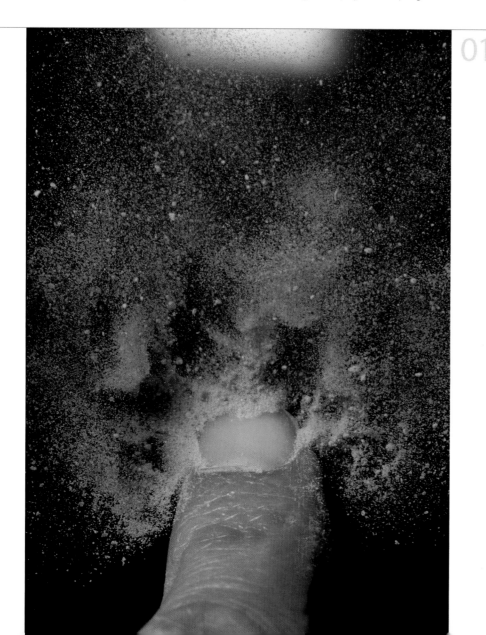

01

02

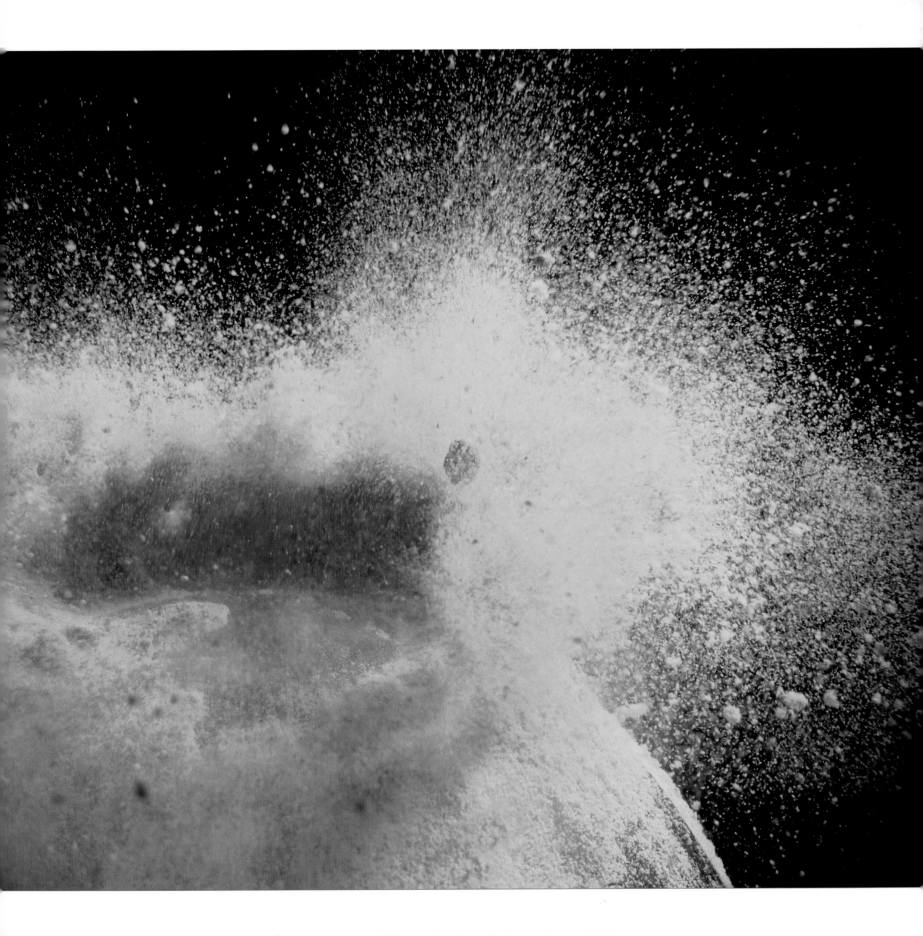

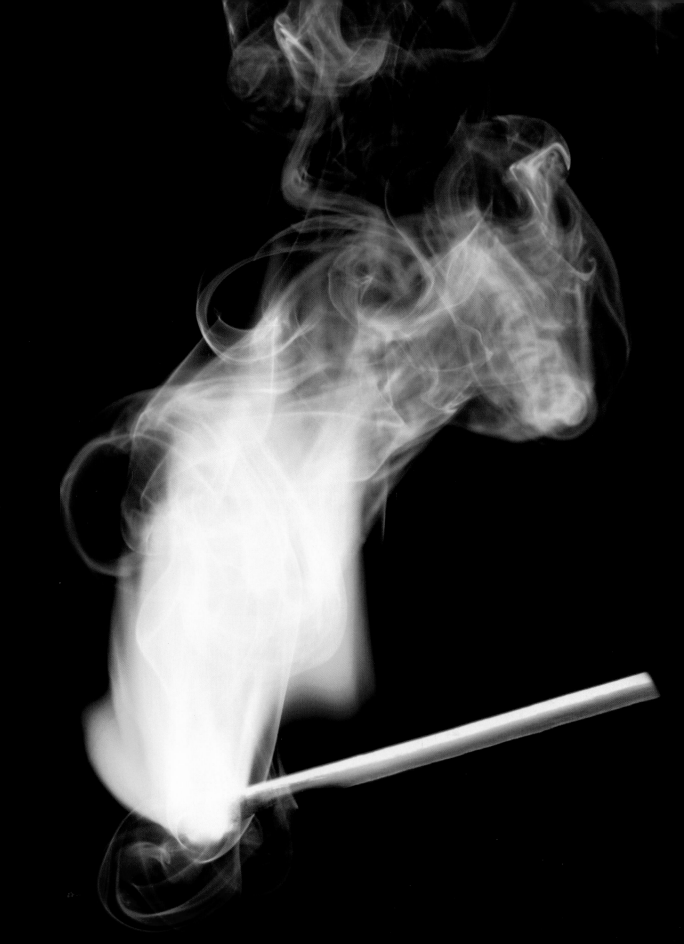

To an aircraft engineer the viscosity of air is a double-edged sword. It produces troublesome drag on the wings but it also forms a viscous boundary layer over the wing which encourages smooth, streamlined flow in the air outside the boundary layer. Sharp edges are a particular menace because they produce another kind of drag due to turbulence, which happens when the airflow detaches from the wing under its own momentum. Aerodynamicists study flow patterns using sophisticated wind tunnels but it is surprising how much can be learned about the behaviour of air, simply by observing smoke streaming from candles, matches and incense cones.

There is no smoke without fire. When a match is struck it momentarily burns with not one, but two separate flames. The first is a white-hot explosion as the phosphorous tip ignites while the second, redder part of the flame appears when the matchwood itself begins to burn.

IT IS SURPRISING HOW MUCH CAN BE LEARNED ABOUT THE BEHAVIOUR OF AIR SIMPLY BY OBSERVING SMOKE STREAMING FROM CANDLES, MATCHES AND INCENSE CONES

01

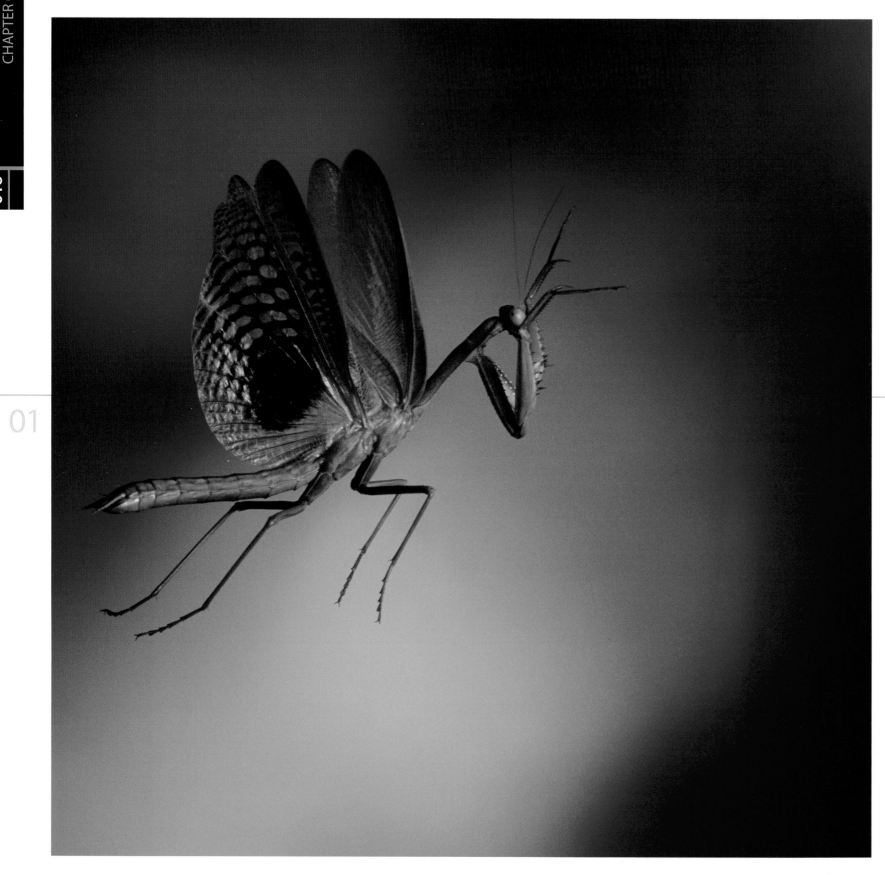

Whenever we are rocked back on our heels by an unexpected gust of wind, we unwittingly bear witness to Newton's famous Third Law of Motion, which says that for every action there is an equal and opposite reaction. It is the weight, or more correctly the momentum of the air that is doing the rocking; we react to the wind and gain its momentum. This idea – elaborated by Newton four hundred years ago – lies at the very heart of flight by animals and aircraft. A hovering helicopter produces a powerful downwash, and it is a similar, but smaller-scale downwash that causes the grass to rustle beneath a hovering hawkmoth. Both are exploiting the same principle: by driving a succession of gusts of air downwards, the wings experience an upward thrust which keeps the body suspended. When an insect hovers it beats its wings backwards and forwards in the horizontal plane, like a set of helicopter rotor blades. This drives an airstream directly downwards opposing gravity. If the insect then wishes to move forward it tilts the stroke plane forward so that the stream is now directed backwards and down: this creates forward thrust as well as lift. A bird coming in to land can produce reverse thrust by tilting its body and wing stroke plane backwards; the airstream now adds a braking force to the body.

These pictures show the beginning and end stages of the wing stroke of a flying mantis. Imagine the insect is flying from left to right – **01** shows all four wings raised, ready to begin the downstroke. Once the stroke has been completed [**02**], and during the fiftieth of a second or so that it took, enough power was created by the wing to maintain the weight of the mantis' body in the air as well as to propel it a few millimetres forward.

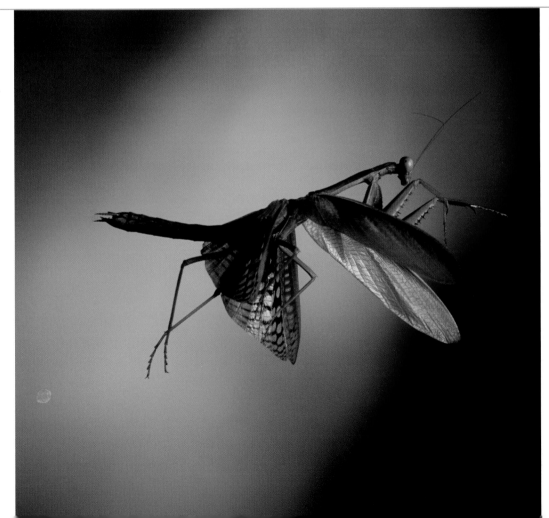

02

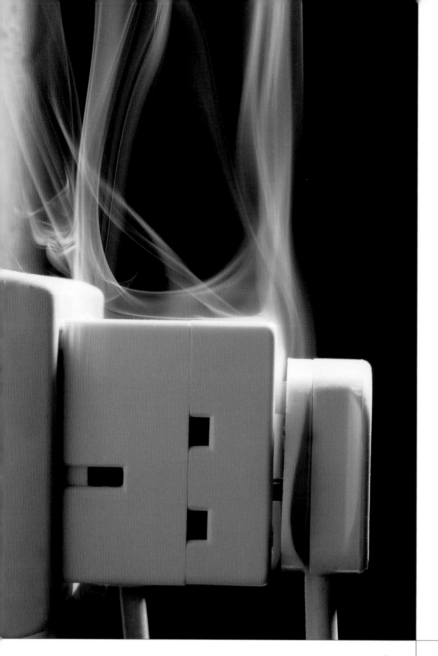

The path that moving air follows is influenced by many factors. As wind tunnel experiments clearly show, the smoother the surface over which air can pass, the less turbulence and resistance results. As well as objects moving through air, the air itself is a dynamic force, constantly on the move due to the influences of temperature and pressure. A burning object converts oxygen into hot gases, which naturally rise. Initially at their hottest they do so in smooth laminar form.

A burning object consumes oxygen by drawing fresh air in from below and exhausting a column of hot gases above. A domestic fire burning in the hearth draws air in from the room and sends a column of smoke up the chimney. The hot gases themselves are invisible, but what we see as smoke is in fact the tiny uncombusted soot particles carried in the gases. With an electrical short-circuit shown here [**01**], or the candle being snuffed out [**02**] the gas rises in smooth, laminar streamlines.

01

WHAT WE SEE AS SMOKE IS TINY UNCOMBUSTED SOOT PARTICLES CARRIED IN THE GASES

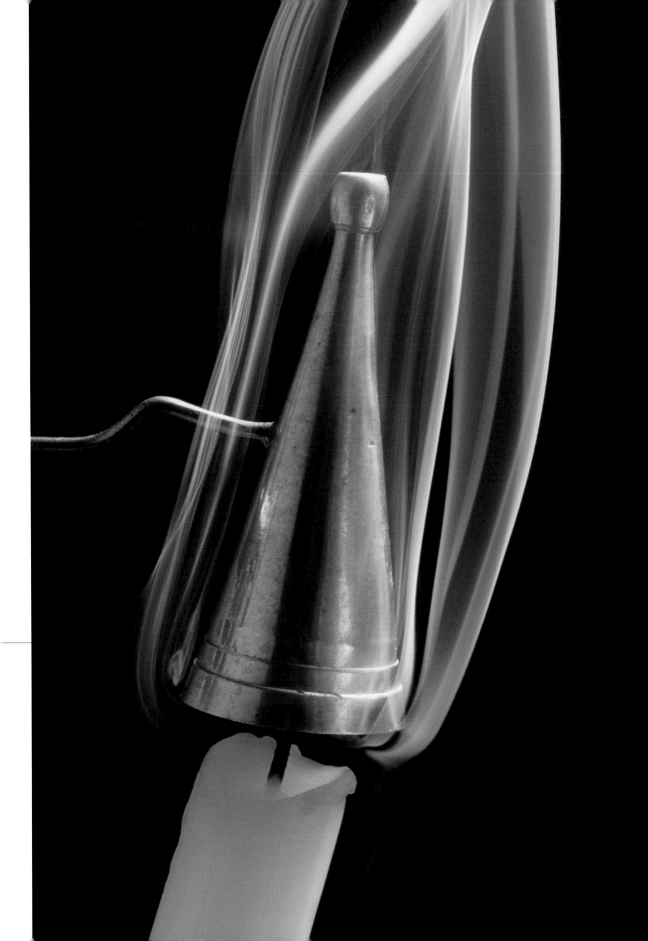

01

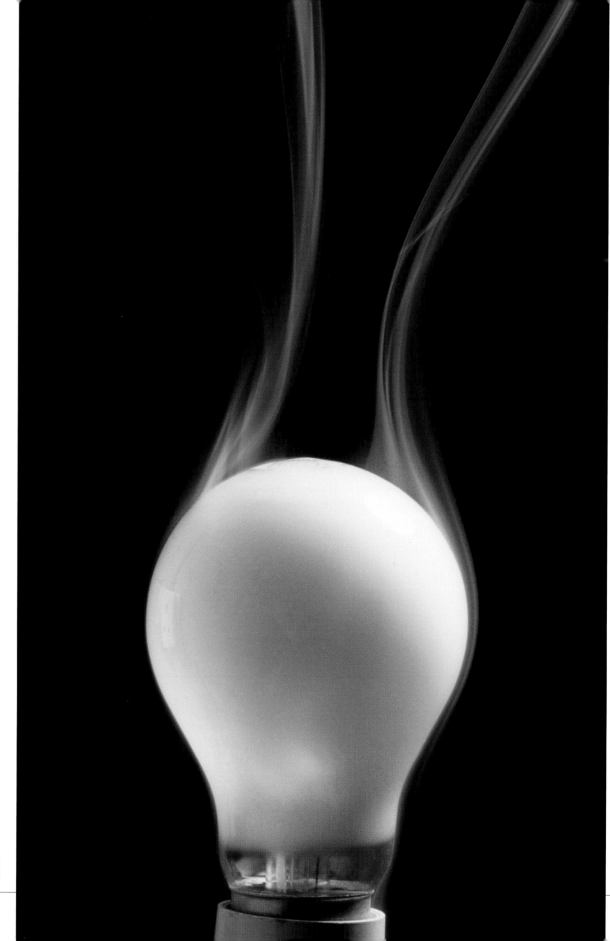

Most of us spend our lives blissfully unaware of the viscosity of the air we breathe: even during exercise we barely feel it as a drag on our lungs. But it becomes painfully obvious to an asthmatic or a hay-fever sufferer, when the tiny bronchi within the lungs are constricted by allergens such as pollen grains. The effect is dramatic – if a bronchus narrows by a half, the resulting increase in airway resistance is not 200 per cent, but 3,200 per cent. The weight of the air might seem insubstantial until we realize that upon the top of our heads rests a column of atmosphere equivalent in weight to ten metres of water. We fortunately do not feel this as a crushing force because our lungs and body tissues are pressurized to the same extent from within.

Laminar flow hugs the contours of any smooth objects over which it passes. This is demonstrated here by placing a burning incense cone beneath a lightbulb [**01**] and an egg [**02**]. The shapes of missiles, bullets, rockets, speedboats and racing cars are all designed to produce streamlined flow and minimize drag, and biological evolution has worked on the same factors over millions of years to build the perfect forms of whales, fish and sealions.

UPON THE TOP OF OUR HEADS RESTS A COLUMN OF ATMOSPHERE EQUIVALENT IN WEIGHT TO TEN METRES OF WATER

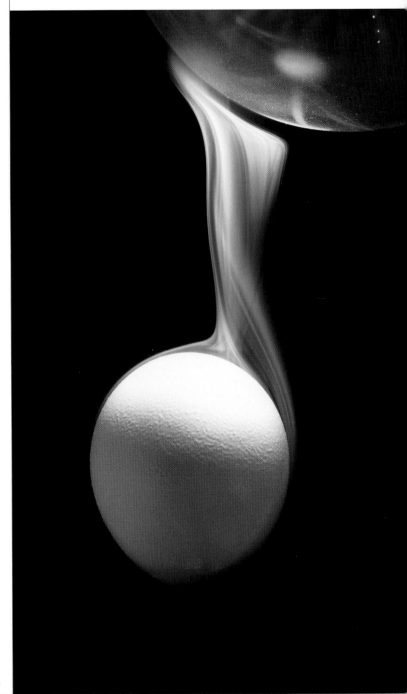

Vortices often form spontaneously in the atmosphere when air of slightly different densities and viscosities come into contact. It is a common experience to see leaves caught up in an endless merry-go-round in the lee of a wall on a windy day. This is an example of a turbulent vortex, that great enemy of the aircraft and sports car designer. In these cases the drag takes the form of random vortices in the wake or downwash of the vehicle. In contrast, the wakes of swimming fish and flying birds contain orderly successions of vortices, an indication of highly efficient propulsion.

As a smoke column rises, the hot gases eventually encounter cooler air above and the smooth streamlines break up into turbulent whirling eddies, as shown in this example of burnt toast [**01**]. Steam is also a rising column of hot gases (in this case air) and particles in the form of minute water droplets. The steam from a hot cup of tea wreaths upwards in a fairly disorderly manner [**02**], but the smooth contours of a boiled egg just removed from the pan impose a more orderly flow pattern [**03**]. Sometimes the transition from smooth to turbulent flow is less abrupt, and an orderly succession of vortices makes a brief appearance [**04**].

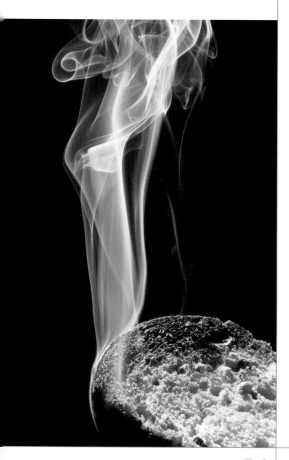

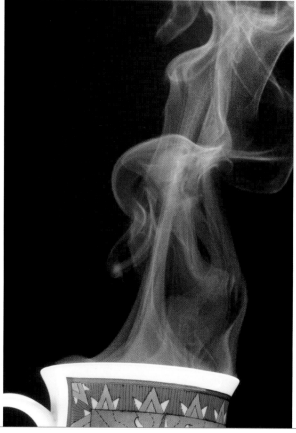

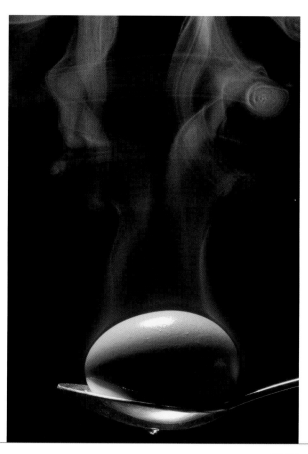

01

02

03

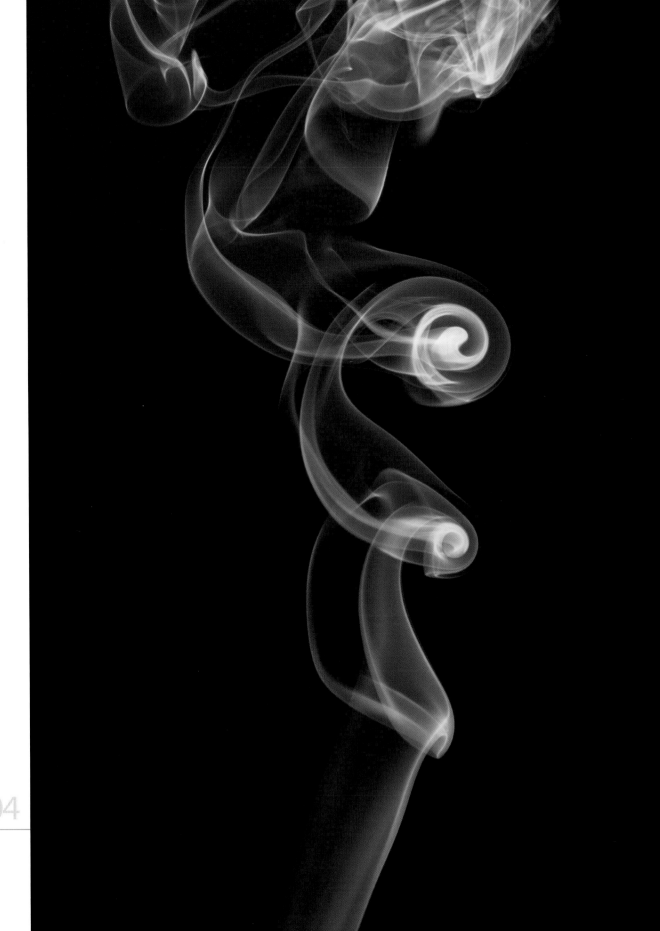

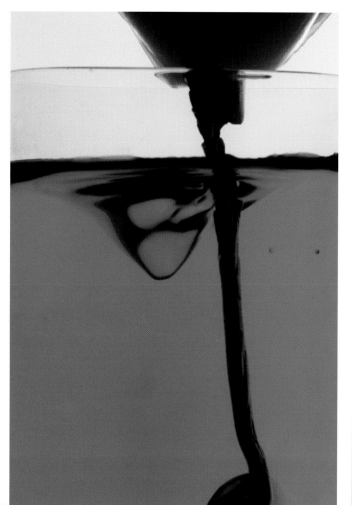

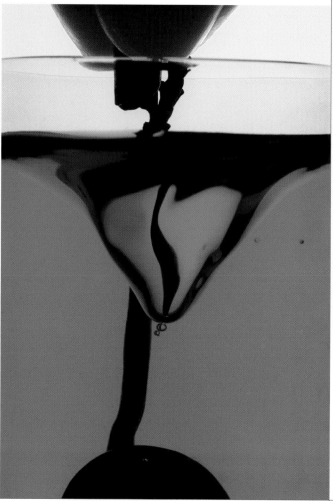

01

02

Water provides a more tangible subject than air. A body of water can exert two kinds of pressure on solid objects in contact with it, depending on its depth and whether or not it is in motion. In the case of an ocean, for example, hydrostatic pressure at the bottom is capable of collapsing a submarine, but it is the dynamic pressure of breaking waves on the surface that breaches sea defences. The laws of fluid dynamics say that hydrostatic and dynamic pressure are interchangeable: when water is set in motion it gains dynamic pressure but loses an equivalent amount of hydrostatic pressure. This law helps us to understand why a vortex develops in a stirred cup of tea or, as is the case here, a glass of stirred green water.

We see the vortex steadily growing in strength [01] and depth [02] as the water is stirred. The water nearer the centre of the glass rotates faster than that at the edges because it is not held back by the walls of the container [03]. Fluid dynamic law tells us that hydrostatic pressure follows the opposite gradient: it falls to a minimum at the centre and rises towards the edges. The water level therefore automatically adjusts itself to this gradient producing the characteristic conical depression around which the vortex swirls.

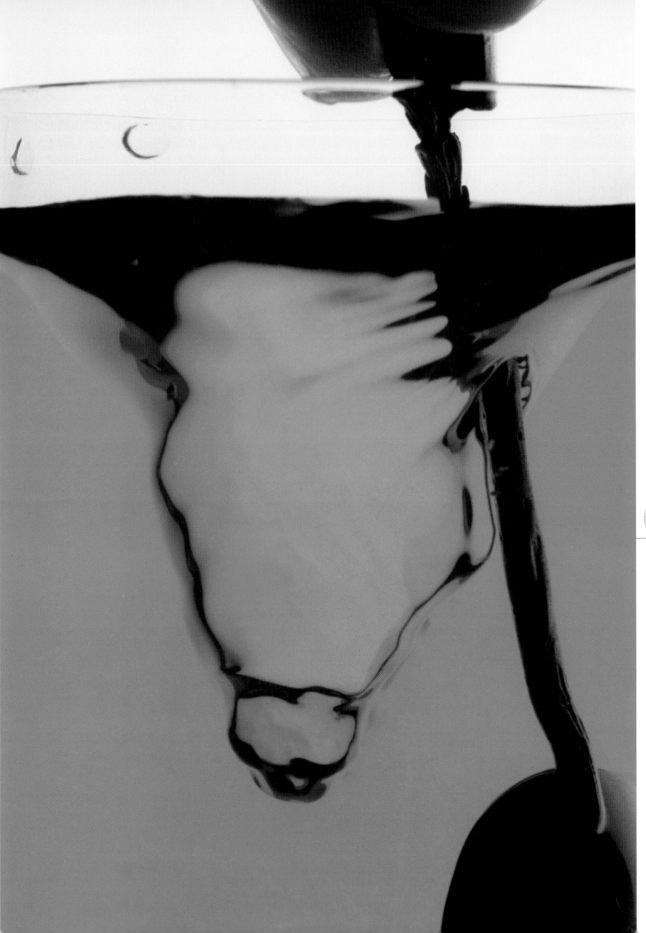

The fact that the static and dynamic forces in flowing water are interchangeable can lead to some curious paradoxes. Take, for example, a garden fountain rising two metres in the air. Logic suggests that the hydrostatic pressure at the base of the column of water is greater than that at the top, otherwise how could the column stand up? In fact, the reverse is true. The static pressure reaches a maximum at the top when the stream reverses and begins to fall. These differences can also be seen in the way a river erodes its channel. A shallow but fast, youthful stream scours out its banks using the dynamic force of its motion. In contrast, a sluggish lowland river, though deep, exercises little dynamic force and tends to deposit silt.

A very powerful vortex can be made by attaching a spoon to a high-speed drill. Illustrated here are the underwater [01] and surface [02] views of such a vortex. The spoon looks stationary but is in fact rotating at about fifty times per second. At this speed, the water in contact with the surface of the spoon begins to cavitate, creating a powerful vacuum that sucks a vortex down from the surface.

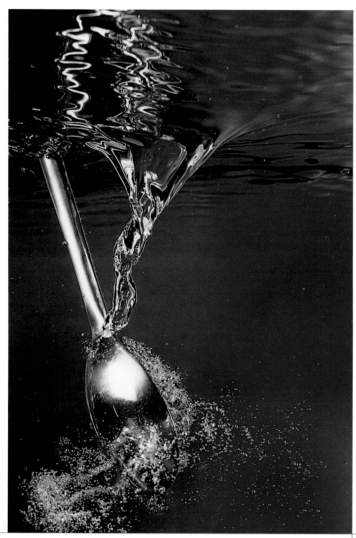

01

02

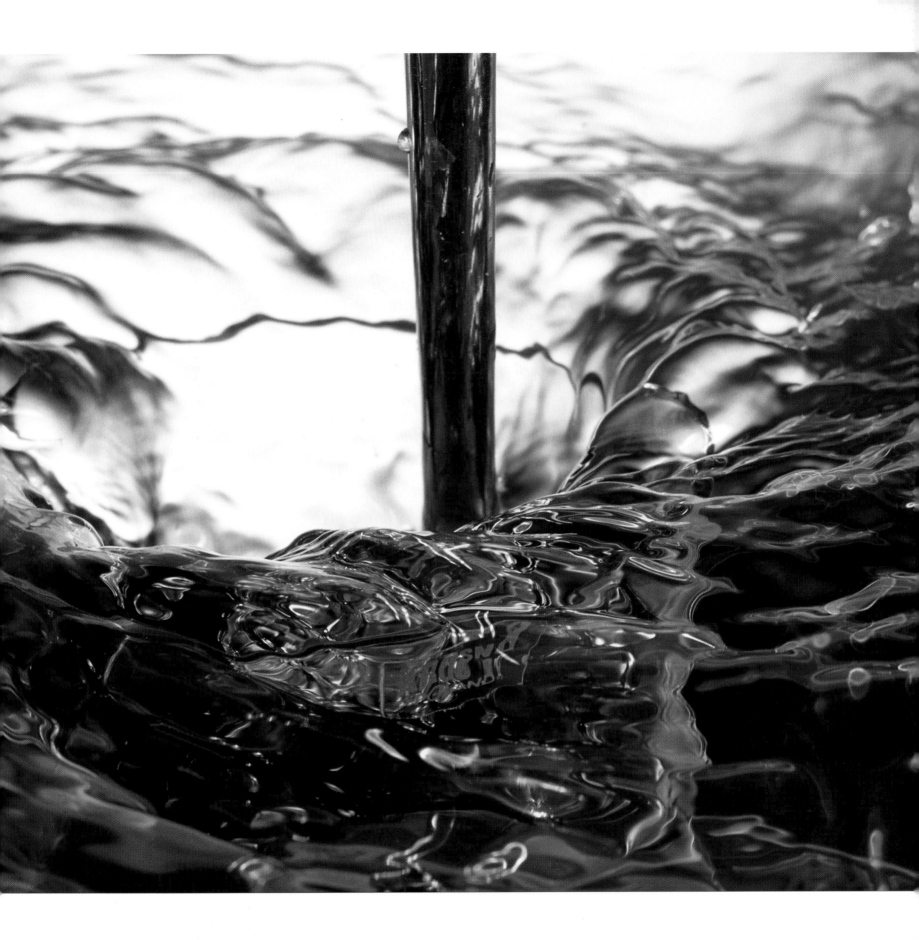

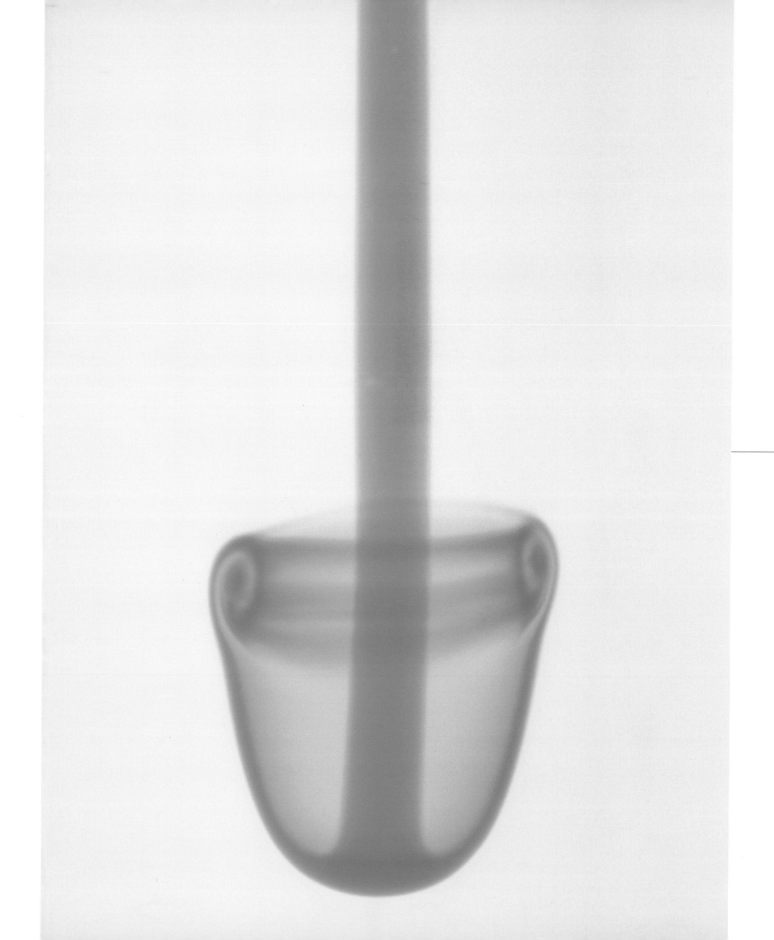

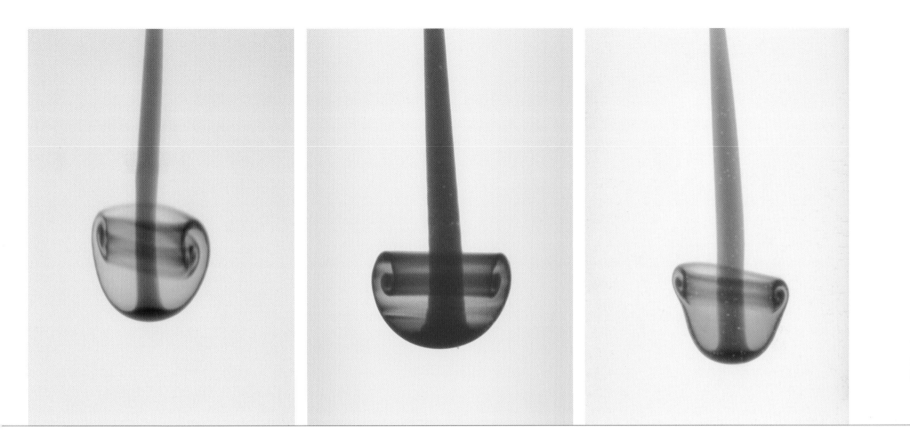

PHYSICAL LAWS DO NOT NECESSARILY DISCRIMINATE ON THE BASIS OF SIZE

The forces at large in the universe are arranged on a descending scale from the mighty to the fragile, and it is the latter that interest us in this chapter. Cosmic forces may seem light years away from these more domestic concerns, but physical laws do not necessarily discriminate on the basis of size. Take 'force' and 'harmony' for instance: two words that, in everyday discourse, seem like opposites – you cannot enforce harmony between a cat and a dog, for example. Yet cosmologists tell us that all the stars, galaxies and nebulae that make up the universe are held in a state of dynamic balance by an invisible force: gravity.

Ring vortices, similar to smoke-rings, can be made by slowly mixing two fluids of different densities, such as water and glycerol. In the demonstration shown here, dyes have been added to the glycerol to make it visible. The glycerol is then introduced into the water as a free-falling streamer. After a while the tip of each streamer begins to flatten out and then rolls back into a ring, which is eventually left behind by the rest of the streamer. The result is the curious inverted toadstool shapes shown here. The rings then lose their shape as general mixing between the two fluids begins to occur.

What we can describe as a fragile force, from the point of view of our own experience of the world, can become a powerful influence depending on scale. Surface tension is one of nature's invisible forces that we only become aware of in our daily lives when, for example, we try to prise a very flat object from a polished wet surface. Water is drawn towards porous surfaces, but it pushes against waxy or water-repellent surfaces – which is why water spilt onto a waxed table rolls up into droplets.

One of the classic methods for measuring surface tension makes use of a small metal disc attached to a spring balance. The disc is placed on the water surface and the tension needed to pull it clear is measured. The demonstration shown here [**01**] was inspired by that particular experiment, the spring-balance being replaced by two intertwined passion flower tendrils. Although you cannot see it, the tendrils have been stretched from above so that their elastic tension is just balanced by the force attaching them to the water surface. **02** shows a similar 'balance of forces' between the elasticity of the coils of the tendril, and the surface tension in a soap film.

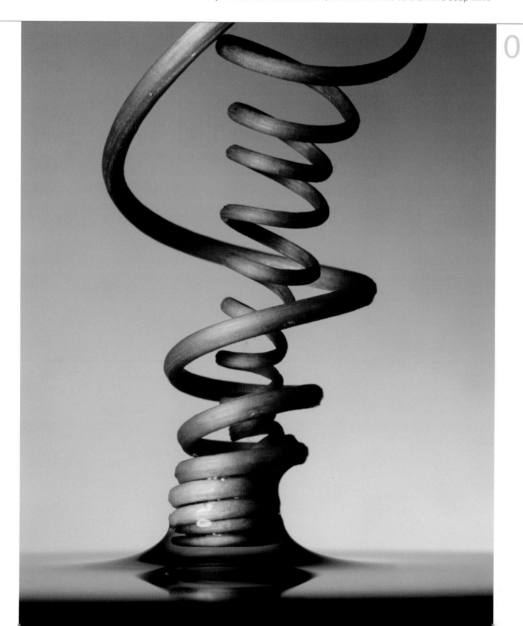

01

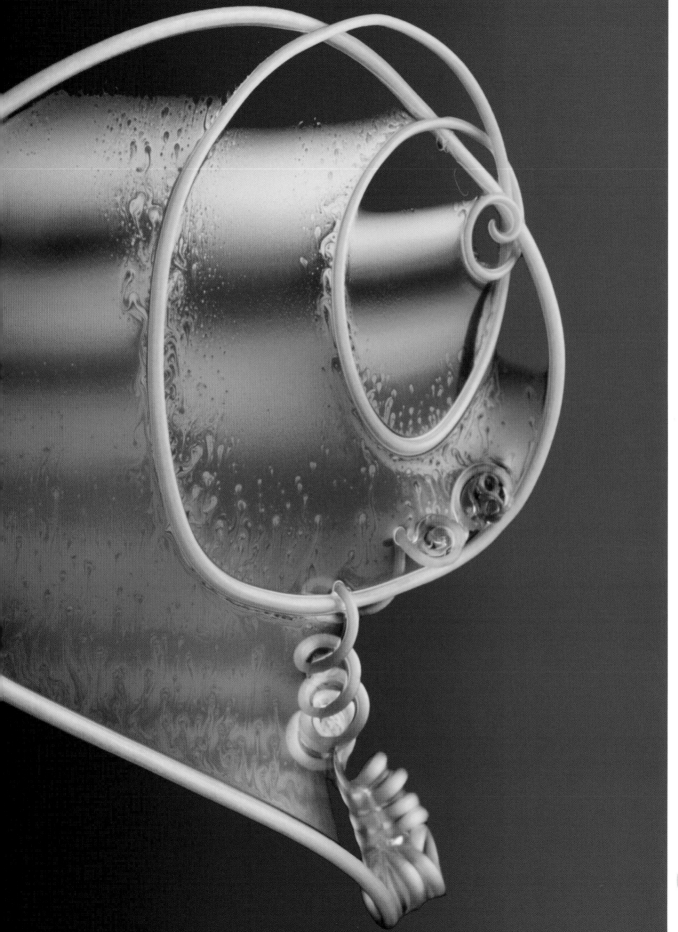

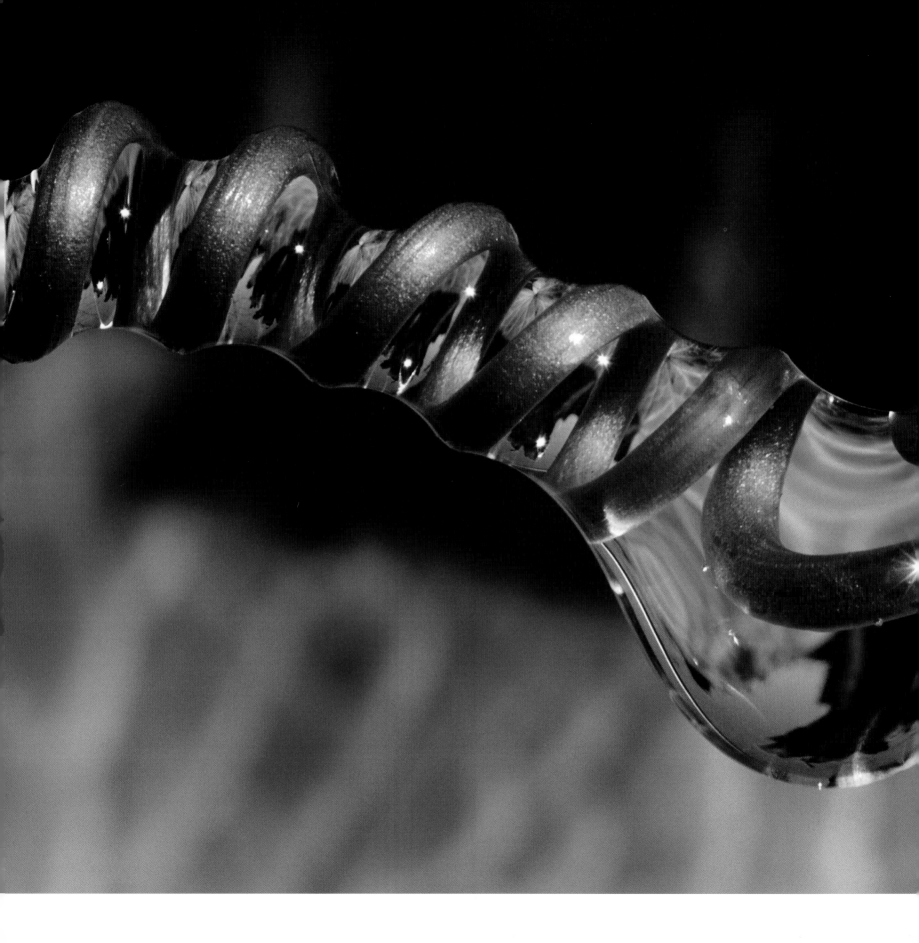

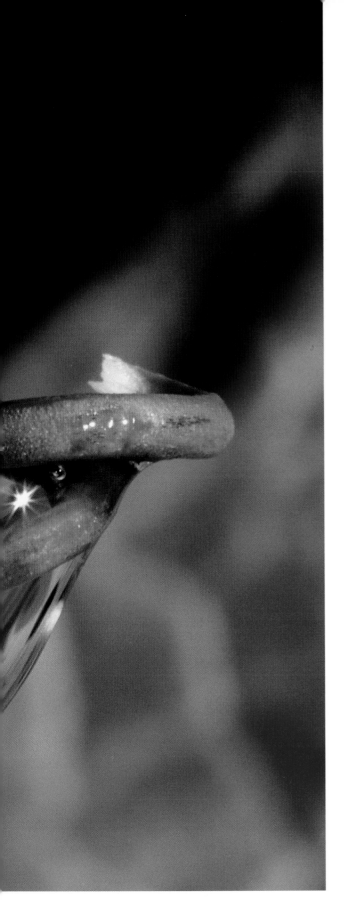

Water droplets with no other influence will form an ideal spherical shape, but when faced with an irregular surface the water will adapt itself in the most economical way. For this reason, aerosols are very effective for airborne drug administration, because they enable the drug to reach the deepest and tiniest channels in the lungs. Ironically, a similar position applies in reverse: a human sneeze is a violent ejection of aerosol particles laden with bacteria and viruses. A cloud of such particles, providing life-support bubbles for their inhabitants, can carry disease over very large distances.

When a surface is full of nooks and crannies such as this passionflower tendril, surface tension arranges the droplet into the best possible fit, but loses perfect symmetry. The resulting shape is a beautiful compromise between the elastic force in the film and the weight of the droplet. The droplet arranges itself so that the ratio between the surface tension and the volume of water is a minimum.

WATER IS DRAWN TOWARDS POROUS SURFACES BUT PUSHES AGAINST WAXY OR WATER-REPELLENT SURFACES

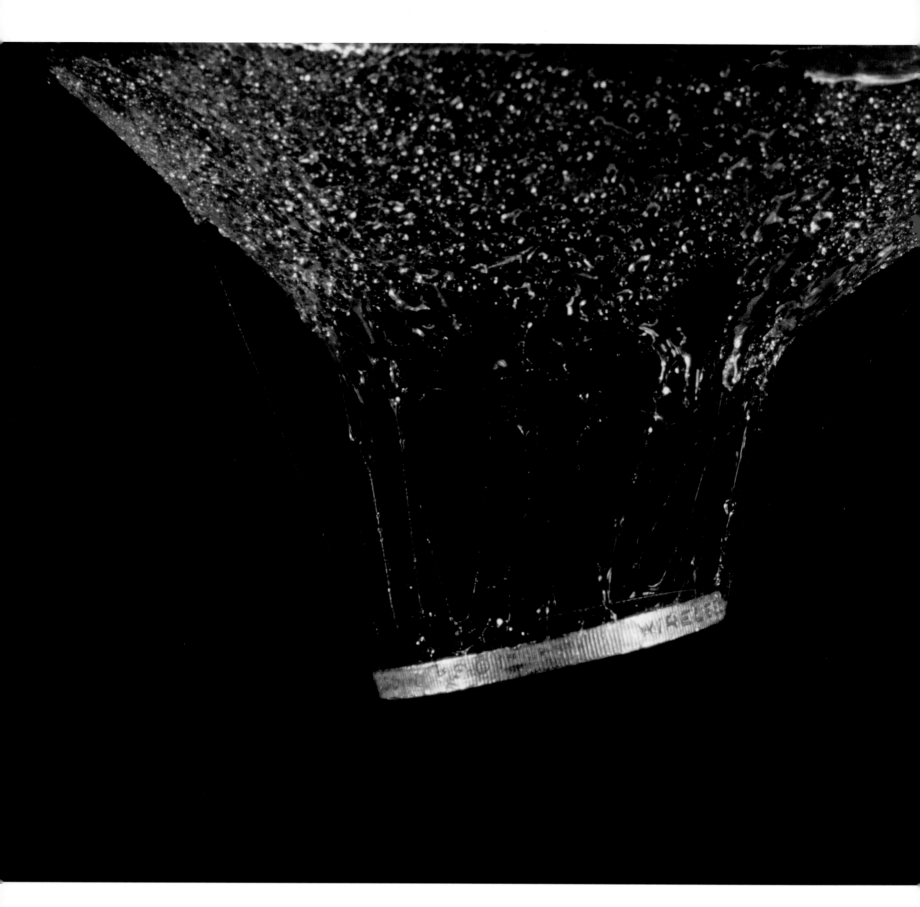

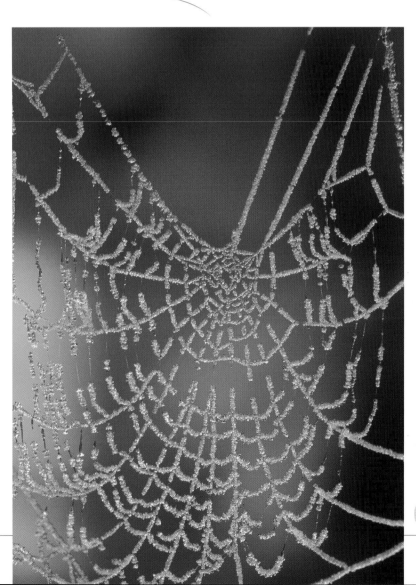

A single thread of spider's silk measures just over a thousandth of a millimeter in diameter, far below what the human eye can see. In fact, it is only visible to the naked eye because it scatters light in the same way that the stars in the night sky shine – by scattering light in the atmosphere. The architecture of an orb web is arranged around a system of structural or radial threads and spiral 'capture' threads. The radial threads consist of two or more individual threads twined around one another to give extra strength and they can only stretch by about 20 per cent before breaking. The spiral threads are single and bathed in glue. They can stretch up to 300 per cent – an adaptation to deal with the struggles of insects caught in the web.

Dry spider threads can stretch by about 20 per cent but this increases to 70 per cent when they are wet, a process known as plasticization. **01** shows a coin dropping through a sheet web, the kind spun by cellar spiders. The coin is stretching the last few threads to their limits and in the next thousandth of a second or so they will have snapped. A spider's web is an elastic scaffolding designed to withstand two kinds of force: the static force due to the weight of dew drops or small icicles [**02**] and the dynamic force resulting from the impact of flying insects, falling leaves and gusts of wind.

Spider's webs provide a very good host for perfectly spherical water droplets. Mathematicians have always been fascinated by surface tension because they recognize in the shapes of droplets and soap films ideal expressions of certain geometric equations. These include the classic 'conic' sections first described by ancient Greek philosophers: the parabola, hyperbola and circle, as well as the curious 'catena', the curve made by a chain suspended between two points.

Ideal water droplets are perfectly spherical in shape. I used this particular web [**01**] to perform an experiment in surface tension. **02** shows the web after it's been lightly dusted with turmeric powder. Close inspection will show a drop-to-drop correspondence between the two webs, except in the hub where the very tiniest droplets have disappeared because they were unable to maintain their surface tension against the effects of the powder.

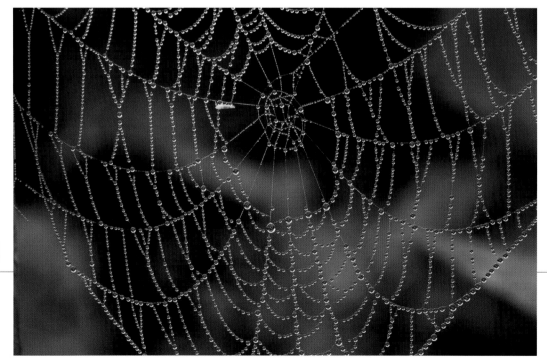

01

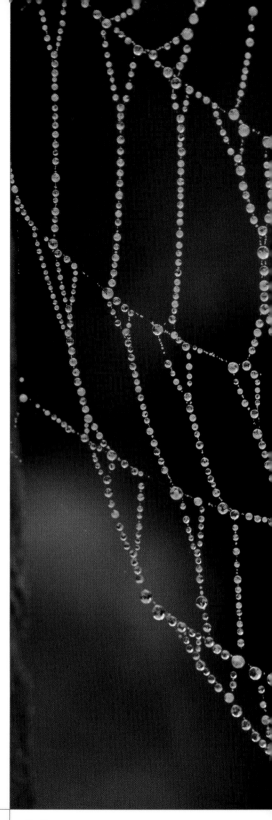

02

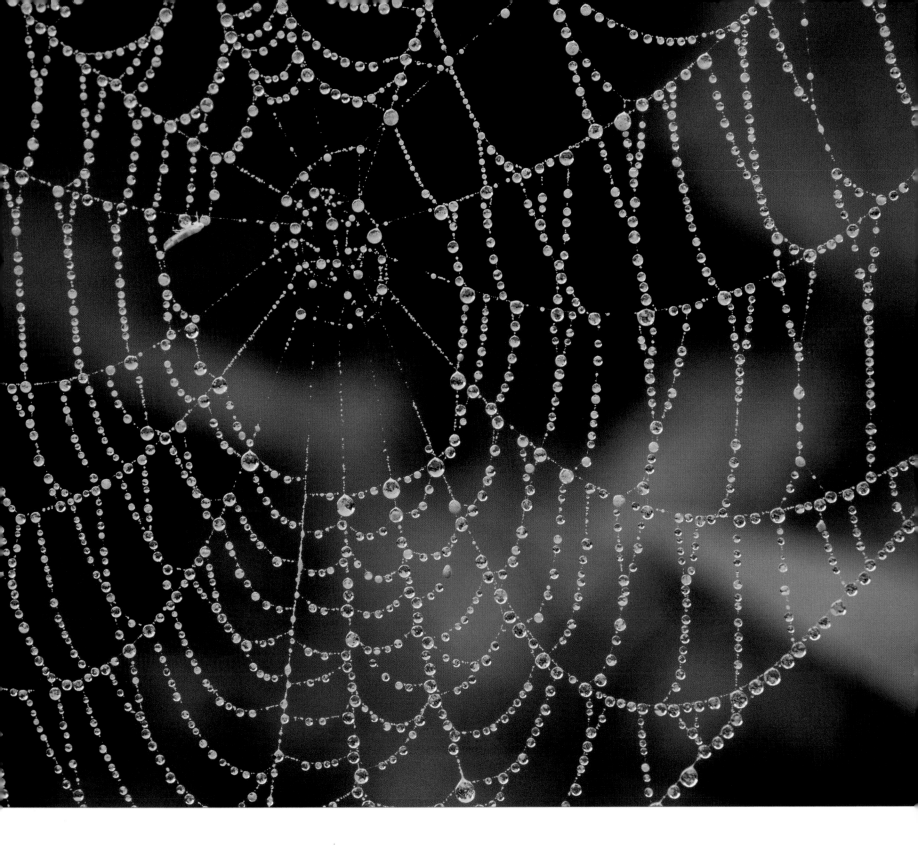

02

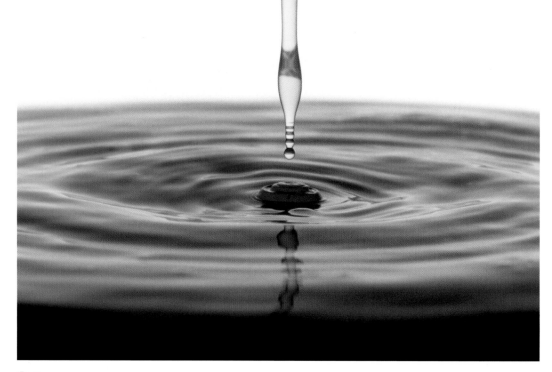

01

SURFACE TENSION, GRAVITY AND MOTION ALL INTERACT IN AN UNPREDICTABLE WAY

Although clouds in the sky are made of water droplets which are heavier than air, the cloud nevertheless does not fall to the ground. The explanation is tied up with the fact that the air loses temperature with altitude. Droplets inside a cloud do indeed tend to fall but eventually the increase in temperature of the air evaporates them. The warm, moist air rises, and upon encountering the cooler air above once again condenses out as droplets. So, ultimately, it is a 'heat engine' that supports the clouds in the sky. When a 'ripe' water droplet finally detaches from the surface on which it has formed, it is easy to understand why: its weight at last exceeds the restraining force of surface tension. However, the situation is more complicated when droplets form at the end of a moving streamer. In these dynamic conditions surface tension, gravity and motion all interact in an unpredictable way and one can only marvel at the resulting forms.

In photo **01** the end of the streamer has pinched into a series of droplets each of which will grow and become detached. Fat, undetached terminal droplets are seen in **02** and **03** and just after detachment in **04**. At least three factors are simultaneously at work here: gravity, the volume of water in each droplet and surface tension. Perhaps not even a computer could predict the actual outcomes.

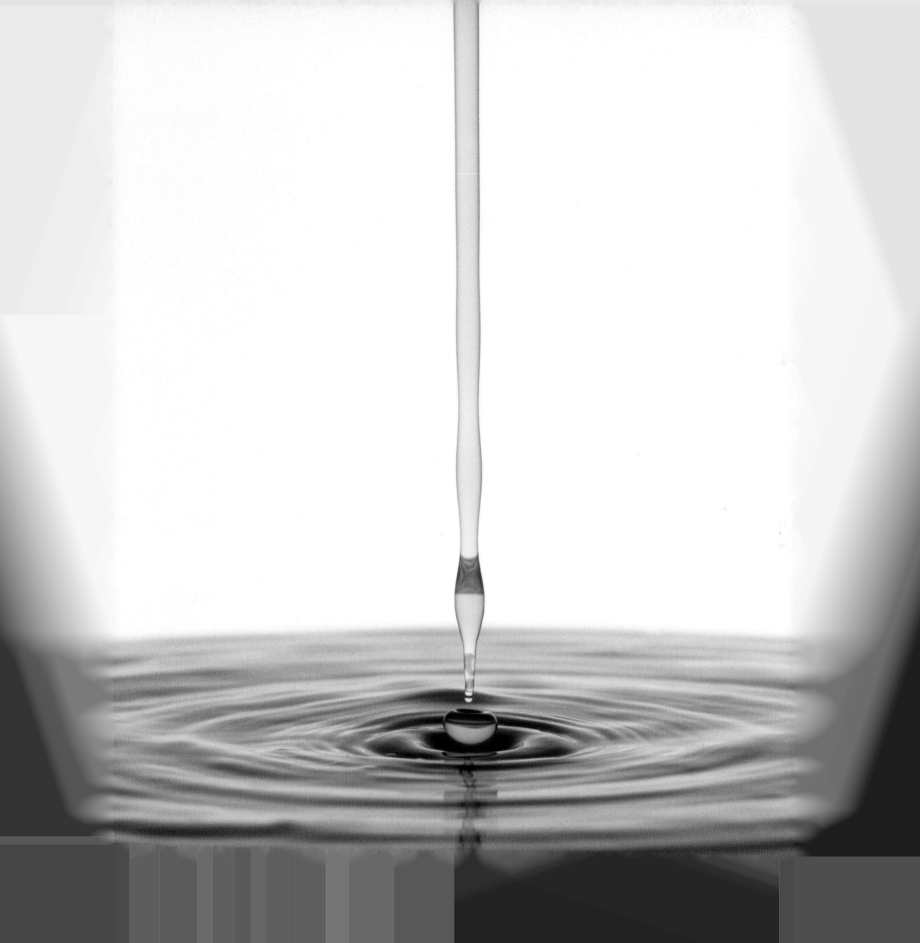

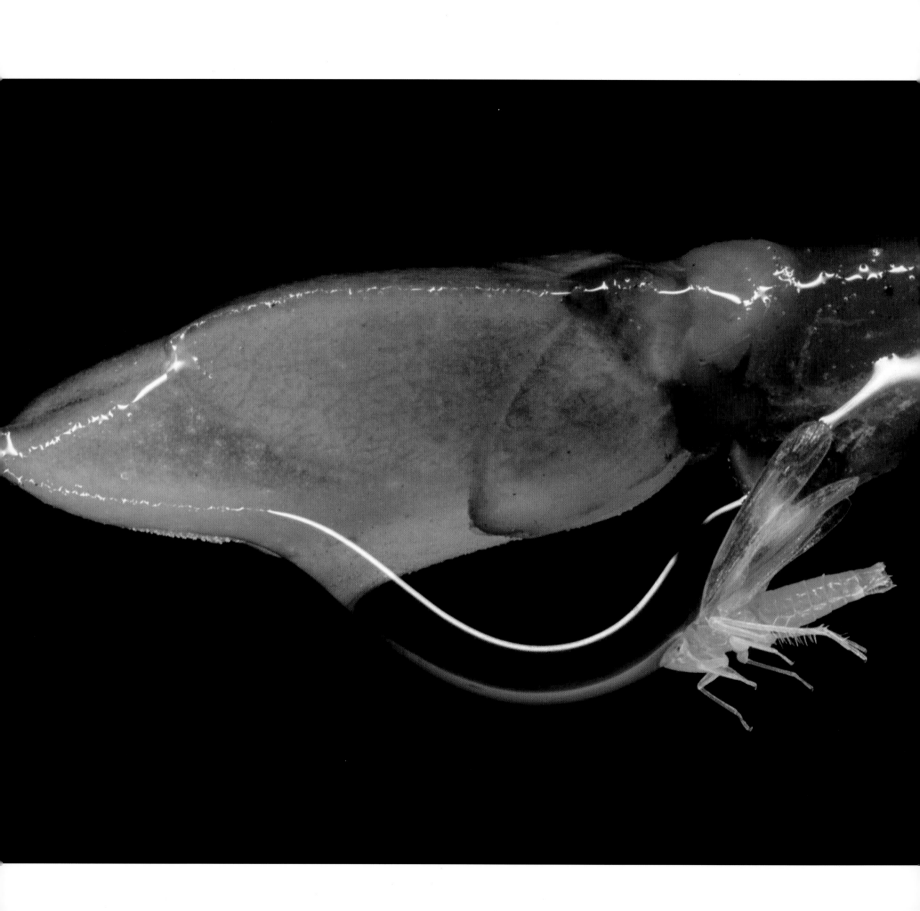

WATER BECOMES AN IMPRISONING, TREACLE-LIKE FORCE

Detergents and soaps that reduce surface tension are referred to as surfactant chemicals. One of the more unusual places to find surfactant is deep inside the human lung, where its role is to prevent spontaneous collapse of the moist bronchi and air sacs under their own surface tension. In nature, many small animals such as insects and pond snails, support their bodies on the surface film. The most notorious of these are mosquito larvae, and one of the most effective methods of controlling malaria in tropical countries is to coat the surfaces of lakes and swamps with oil, which reduces the surface tension and effectively drowns the larvae.

In nature, countless numbers of small animals meet their end by becoming accidentally caught up in small environmental forces rather than falling victim to disease or predation. Few ever die from old age. To that extent, nature is extremely profligate, and wastage occurs on a staggering scale. Most of the tiny insects trapped in spider webs are ignored by their owners and succumb eventually to exposure or starvation. Dragonflies in peak condition, and still busy with the act of pairing and mating, are cut down in their millions with the very first night-time frost of Autumn.

Studying the properties of nature at an extremely small scale reveals events with which we, as humans, are entirely unfamiliar. Water becomes an imprisoning, treacle-like force, engulfing life in a series of stunning shockwaves and ripples.

High-speed photography shows what happens when a small crawling beetle is struck by a raindrop. In photograph **01** we can see the reflection of the beetle's back in the drop microseconds before it strikes.
At the moment of impact [**02**], the drop suddenly looks as though it were made of treacle, draping itself around the insect's body. The folds in the surface of the drop are in fact shock waves set up by the impact.

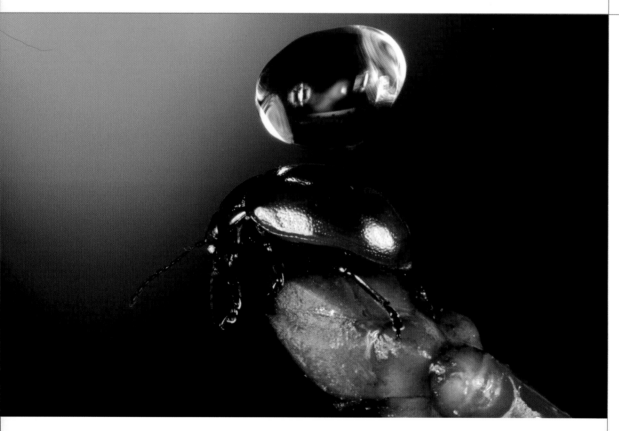

01

02

IN NATURE, COUNTLESS NUMBERS OF SMALL ANIMALS MEET THEIR END BY BECOMING CAUGHT UP IN SMALL ENVIRONMENTAL FORCES

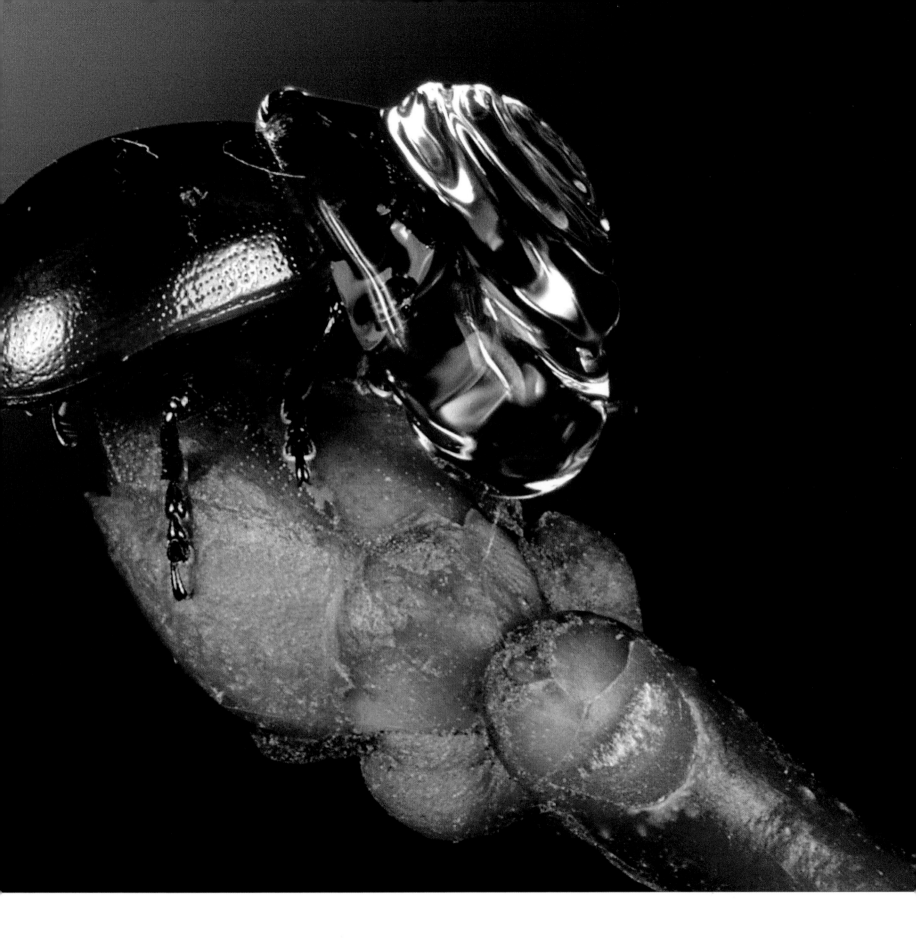

02

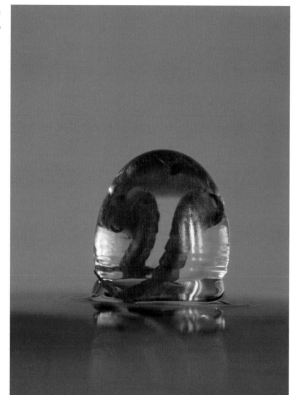

Surface tension's ability to trap minute objects makes it possible for water droplets to help in the dispersal not only of micro-organisms but sometimes also small seeds and insect larvae. Mosquito larvae breeding in the bowls and cavities of trees are washed down by rain and dew. The very force which can spell the end for an insect, imprisoned by the insurmountable power of surface tension, can also create the perfect transit pod, carrying a micro-organism or seed in a bubble of protective safety from one place to another.

This photographic sequence follows the paths of drops falling towards a still water surface. The drops carry a cargo of a pair of live mosquito larvae. The whole of a mosquito larva's skin is porous, and they cannot avoid being imprisoned within the droplet like tiny fish in a water-filled balloon. Struggle as they may, there is no escape until the droplet hits the water.

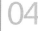

04

03

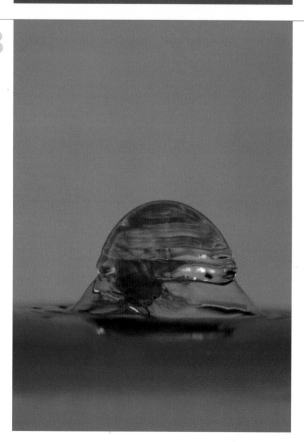

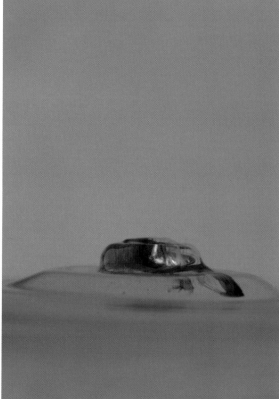

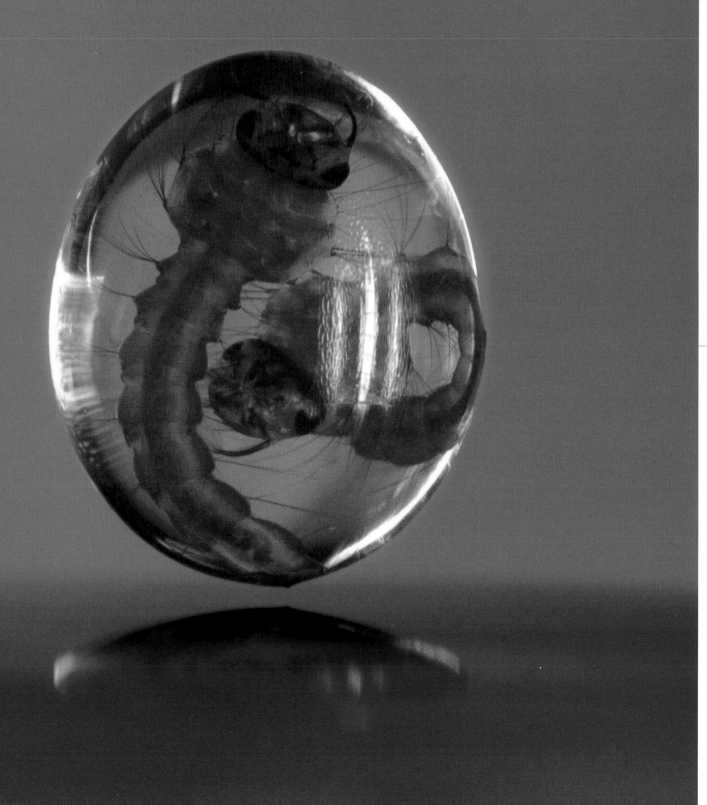

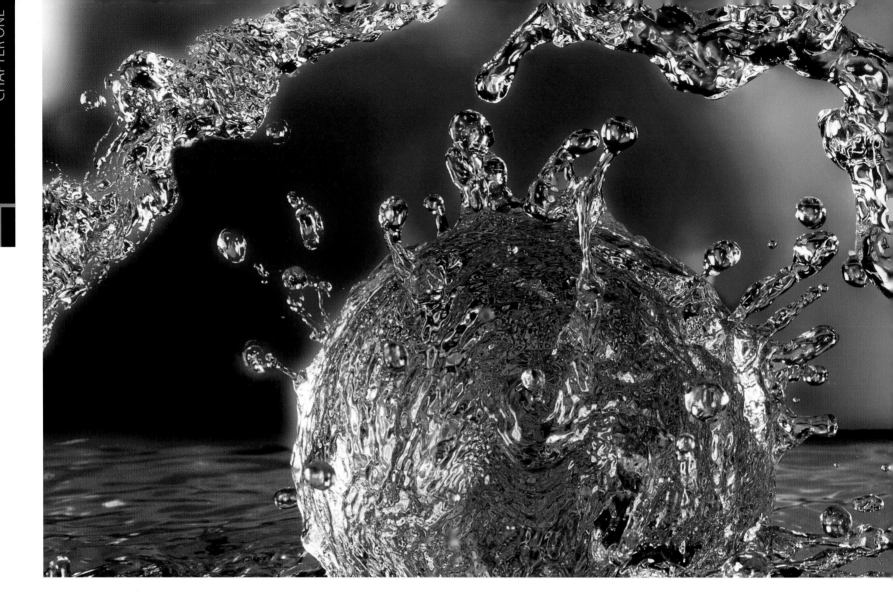

Surface tension is the force that holds a raindrop together and, since it is a relatively weak force, raindrops cannot exceed a few millimetres in diameter. Hailstones, on the other hand, are not influenced by surface tension and can be the size of tennis balls. It would only be possible to grow a tennis ball-sized raindrop in the weightless conditions of outer space. However, we can cheat gravity for a brief moment by bursting a water-filled balloon in mid-air. The amazing spectacle that this produces shows us the suprising and original images that can be revealed by studying the processes at work in what we would usually consider 'instantaneous' events, which leads me on to my next line of enquiry.

02 had to be taken at the precise moment of bursting the water balloon; a few milliseconds later, it has already dissolved into spray – the orange colour visible is the remains of the balloon skin. **01** shows how it is possible to produce the appearance of a ball of water by exploiting viscosity. A glass sphere was placed in the water and a jet from a small pump mounted behind the sphere was directed at its rear surface. The jet streams forward over the sphere, clinging to its surface through viscosity and throwing out curious spiky droplets in the process.

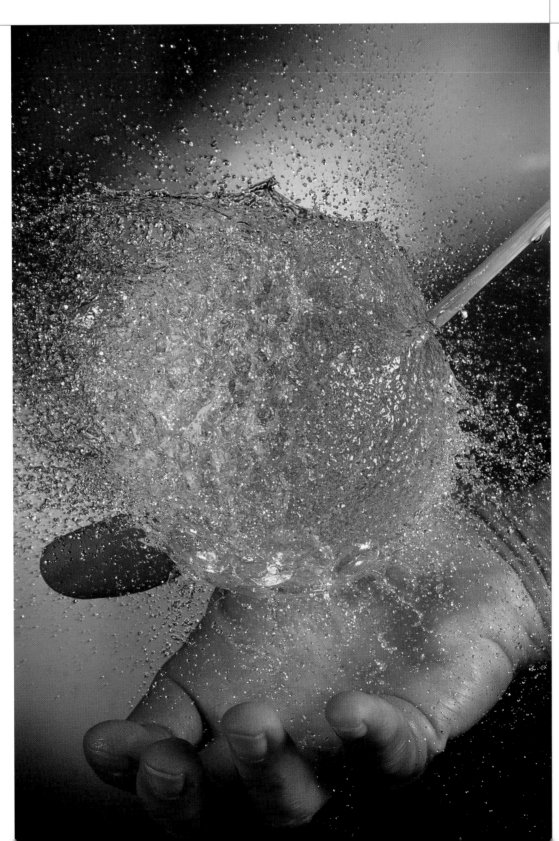
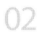

CHAPTER TWO
FLEETING FORMS

It is easy to find situations where a quicker eye might have served its owner better: you might have caught the vase that was knocked off the table, or the fielder may have made that 'easy' catch. These simple, everyday mistakes show that our brains need time to capture and digest an image. But how much time? How time is perceived psychologically is a fascinating subject, and in this chapter we observe that time can be made to bend to man's needs through the lens of a high-speed camera. Fleeting events can be captured and perused at leisure so that their brief, highly compressed evolutions become clear for all to see. The events illustrated over the coming pages are mainly commonplace, yet once frozen in the spotlight they reveal more than might be expected – water begins to flow like molten glass, forming sheets, chandeliers, sombreros and surreal landscapes; bubbles develop a lunar surface and simple soap films flash through the colours of the rainbow. We are watching events that ignite to a new level of perfection and, within milliseconds, are snuffed out.

ARTISTS AND POETS SAW A KALEIDOSCOPE
OF SHIFTING FORMS AND LIGHT THAT ELUDED
FORMAL DESCRIPTION. WATER SYMBOLIZED THE
METAMORPHOSIS OF LIGHT

02

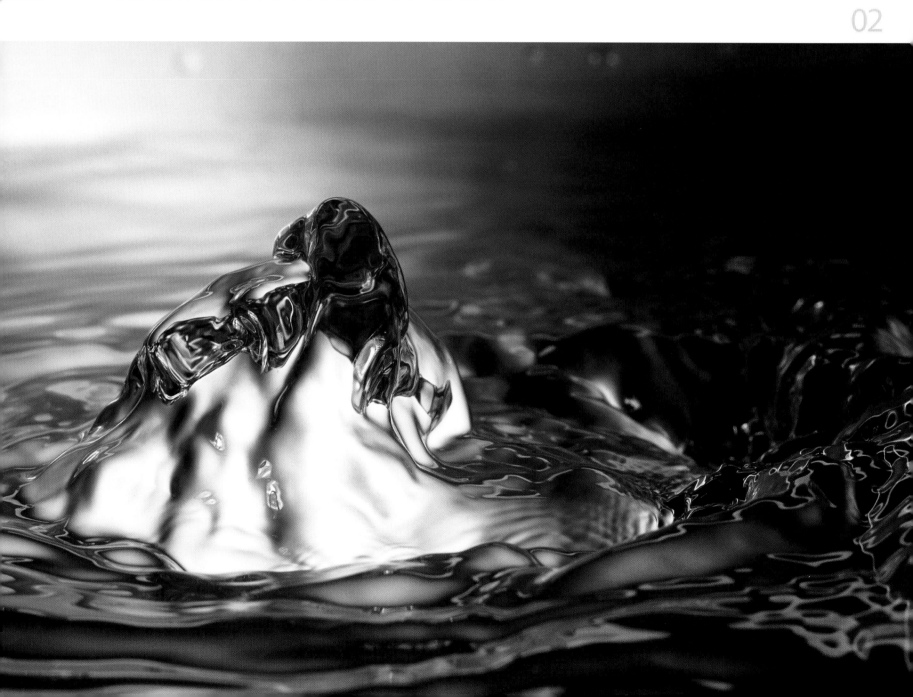

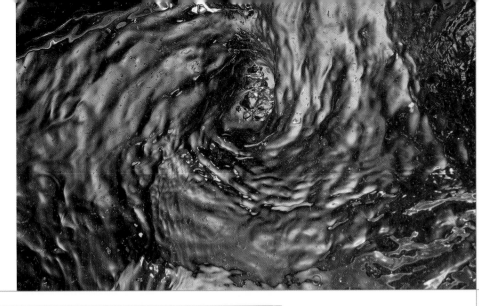

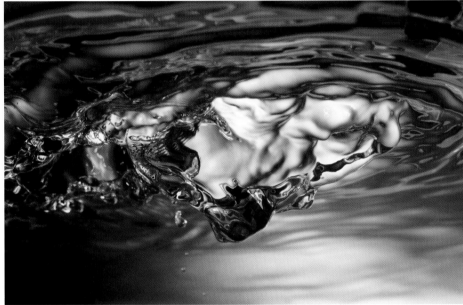

Water intrigued philosophers of the ancient world. The Greek philosopher, Thales of Miletus, even claimed that everything was made of water. It is not difficult to understand why they were so fascinated, because water possesses shape, yet has no independent shape of its own (it will borrow the shape of any vessel that it occupies). This was a powerful paradox for those obsessed with the idea of a world constantly in a state of flux. Water was seen as the material capable of mutating into anything else in the physical universe. To the impressionist painters of nineteenth-century Europe, this unattainability of a clear image was a blessing in disguise. Modern high-speed photography does the exact opposite by eliminating change, and by focusing our attention on plastic form it creates its own version of surrealism.

Water spiralling down a drain-hole [**01**] provides the eye with a discernable clear pattern of form, but more often we are only left with an impression of motion. A small geyser welling up from below a water surface becomes transformed into a virtual landscape of mountains, folded hills and valleys [**02**], while a similar image, viewed upside-down, could be seen as a stormy skyscape [**03**].

In his poems and paintings the English mystic William Blake offered us a vision of nature's 'perfect symmetry', yet even he could not have guessed the forms hidden in the wakes of simple objects moving through water.

In this series of images the camera is looking up from beneath the water towards events happening on the surface, showing two stages in the development of the wake pattern created by a magnifying glass towed 'flat–side on' through the water. At the start of towing [**01**] a pair of vortices begin to snake down the sides of the glass, then quickly coalesce to form the mature wake – a kaleidoscope of turbulent motion [**02**]. These pictures show what engineers have known for many years: turbulence is associated with sharp edges.

01

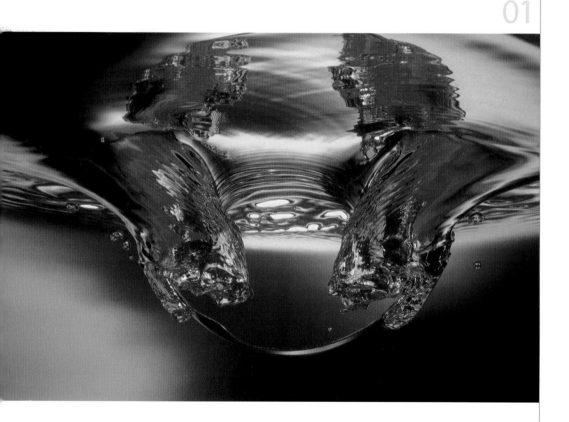

02

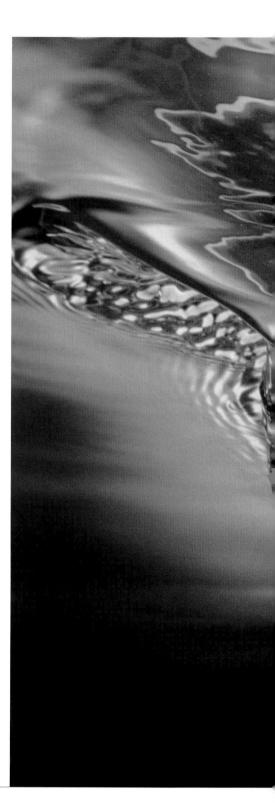

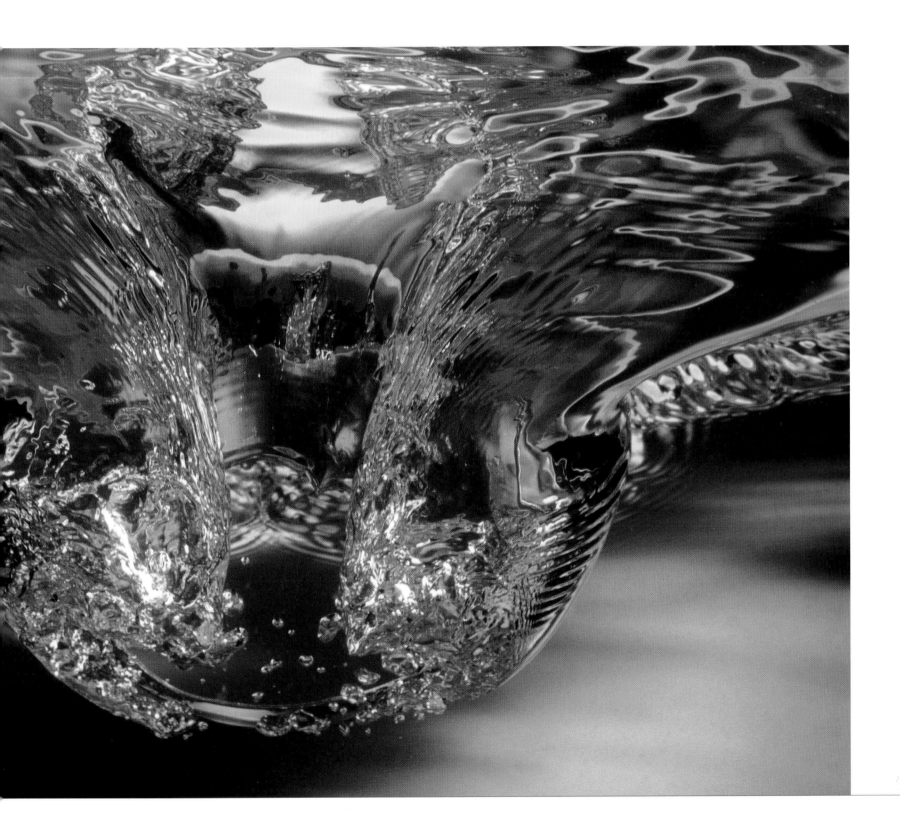

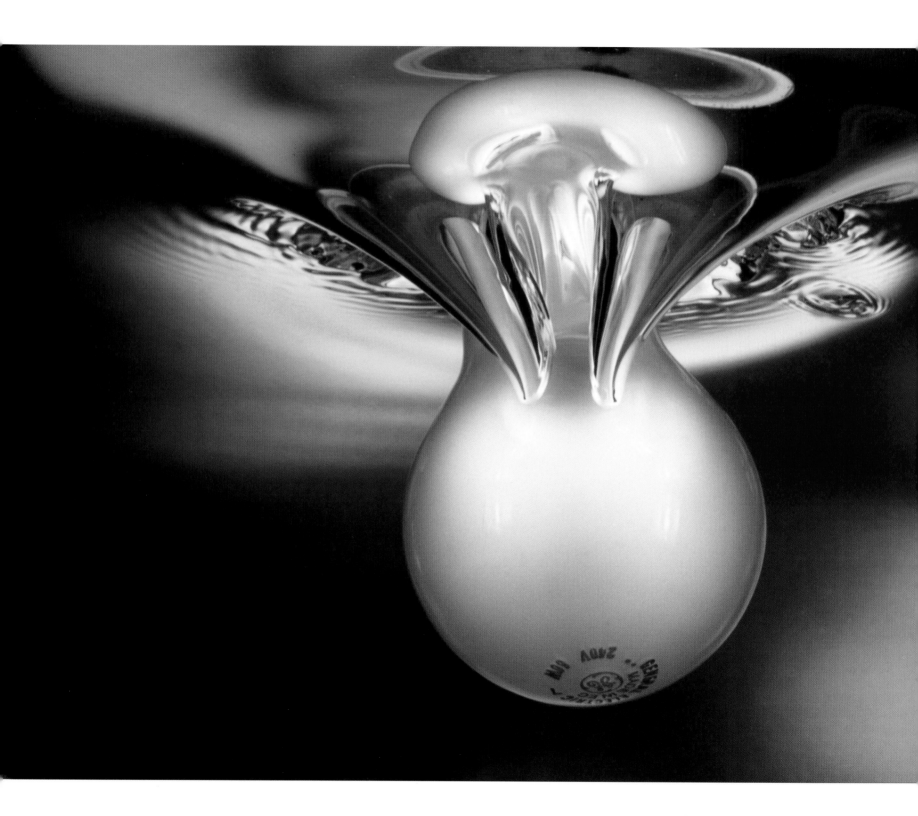

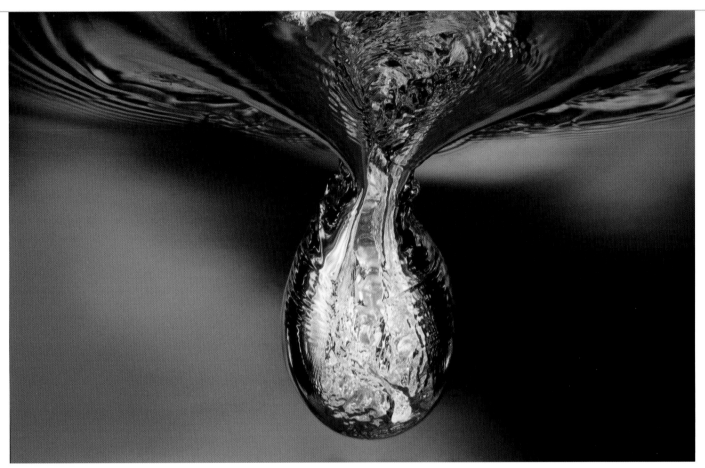

Although the various shapes assumed by water in motion are interesting in themselves as artful expressions of nature, they also reflect the subtlety of the mechanical laws that underlie their formation. The physical world is a treasure house of such phenomena, capable of giving inspiration to designers, artists, engineers or anyone else interested in the concept of form in the service of function.

The smooth rounded form of a domestic light bulb [**01**] encourages streamlined flow and we see little evidence of turbulence except around the narrow neck of the bulb where, once again, a vortex pair makes its appearance. A tablespoon has both a curved surface and sharp edges, and the pair of vortices forming around the neck of the spoon penetrate deeper than in the previous case [**02**].

The revelation of these forms is dependent on reframing an event that is too fast to see with the human eye. Our view of the world however is not universal. The world at large does not pace itself on the speed of the human eye, but television does. The framing frequency of television and video is about 25–30 frames per second. This is the minimum frequency at which our brains fuse a sequence of separate images into an impression of seamless motion. Just below this frequency the screen would start to flicker and the picture would seem like a speeded–up slide show. This indicates that our brains need a minimum of a thirtieth of a second to register an image as a separate entity. Compared with this, the brain of a fly for instance is far quicker: even if TV were broadcast at one hundred frames per second, the fly would still see a slide show.

A plastic ruler drawn flat-side-on through the water displays a wake heavily influenced by sharp edges, the vortex pair swirling right to the tip of the ruler. The vortices are regions of negative pressure in contact with the rear surface of the moving object and are the major source of drag. As the speed of motion increases so does the drag, and the process is compound: a doubling of speed produces a quadrupling of drag.

THESE PICTURES SHOW WHAT ENGINEERS HAVE KNOWN FOR MANY YEARS: TURBULENCE IS ASSOCIATED WITH SHARP EDGES

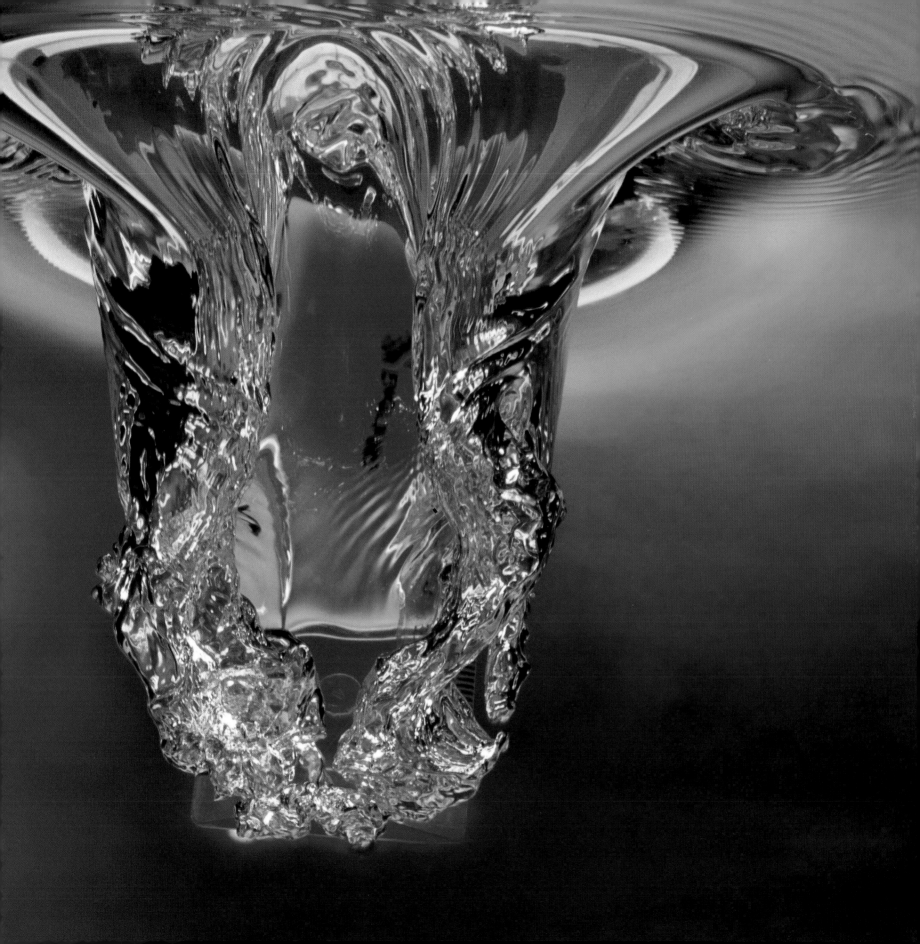

01

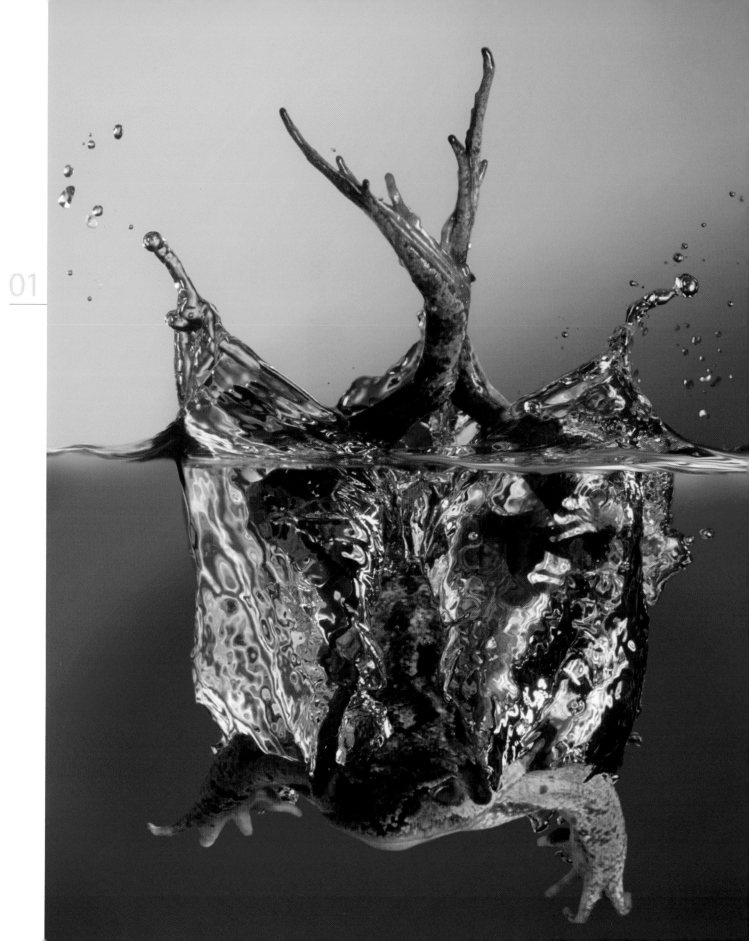

In the first chapter the surface film of water was seen as a rather static thing, like the elastic skin of a balloon. But whenever rapidly moving objects try to pass through it, its dynamic qualities are revealed. What happens when surface tension is stretched to and beyond its limits? I started to experiment with isolating the moment when this happens with the use of high-speed photography designed to be triggered at the precise fraction of a second that the surface is broken.

The glistening shroud of film enclosing the body of this diving frog [**01**] will, in a few milliseconds, become stretched to breaking point and snap back towards the surface. This event has just happened in the case of the dropped egg [**02**]: all that remains of the original envelope in this case is a shrunken cone of film reflecting the colours of the egg sinking beneath it.

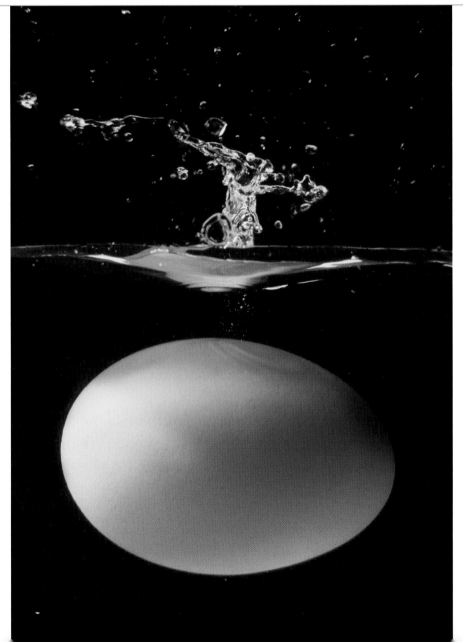

02

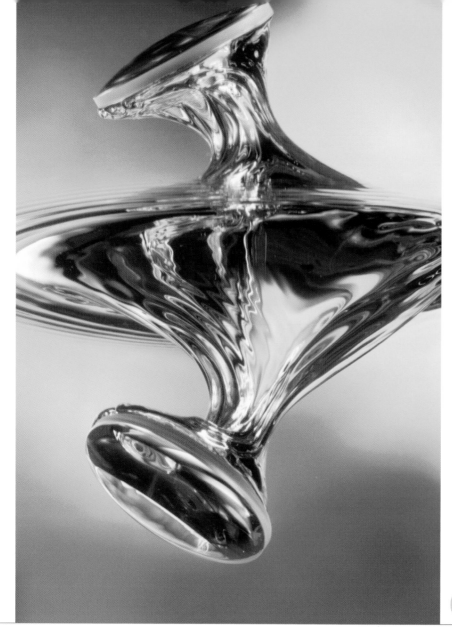

01

One of the most difficult parts of recording micro-second events is not the image capture itself, but trying to imagine the event in the first place. Where do you look for it? This may involve days, even weeks of trial and error. At first, the idea of dropping coins and lenses into water seemed as unpromising to me as it might to you and, although I sensed that there was a kernel of interest inside it, I only began to obtain results when I set the exposure of the camera within a tiny window of time surrounding the actual impact of the object on the water surface.

This sequence shows the distortions of the surface film that appear when a glass lens is dropped side-on into the water. As it enters the water the lens drags down from the surface a conical sleeve of film [**01**]. As the sleeve becomes placed under ever increasing tension it finally detaches, leaving the lens to continue its downward journey to the bottom [**02**].

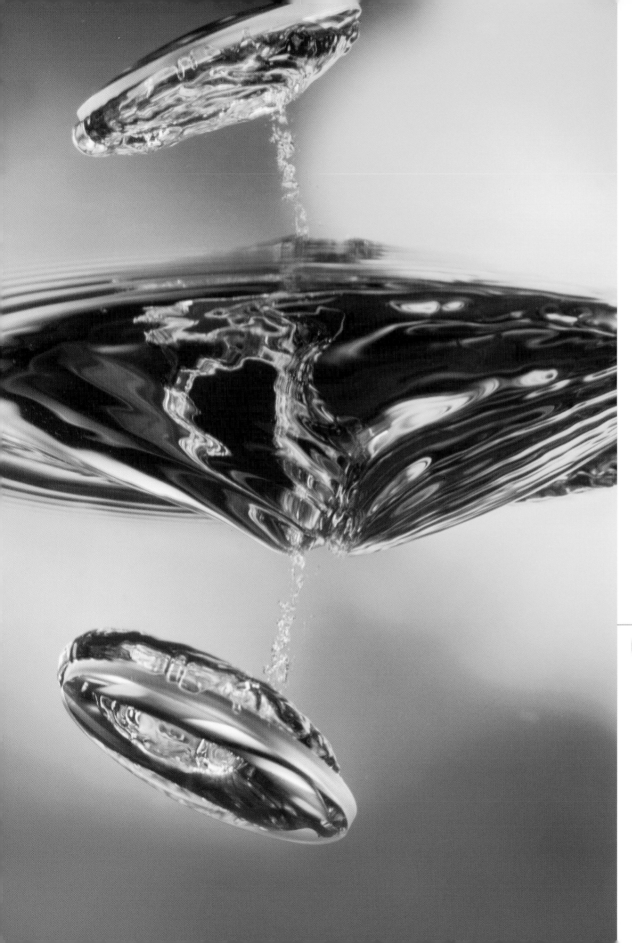

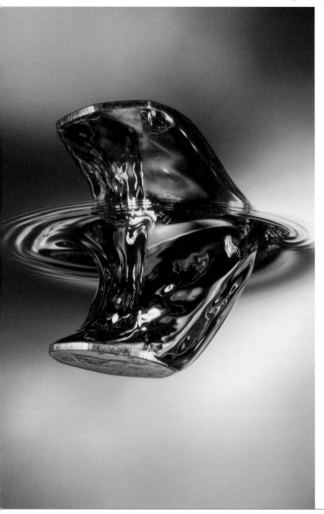

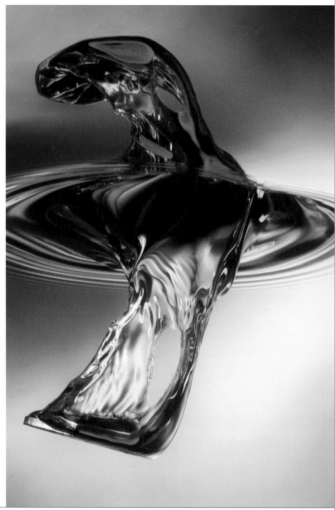

As with the demonstration with the lens, we can see here that a similar effect is created by dropping a coin through the surface film. What began to be revealed was that in order to pass through, an object pulls with it a piece of the surface which closes up behind and eventually pinches off as the object descends below the surface of the water. The object is actually contained within a bubble, broken off from the water surface, as it passes through.

These images are separated by only a few milliseconds, and the growth and decay of the event is very rapid. The different stages were recorded by triggering the camera with a thin laser beam placed at millimeter intervals below the point at which the coin was dropped. The coin pulls the surface with it as it hits the water [**01**]. **02** shows the surface tension sleeve literally pulling itself apart, half of it recoiling to the surface, the rest detaching along with the coin as a bubble [**03**]. At a slightly later stage than that illustrated in photo **03**, the bubble detaches from the coin. This is the point at which the naked eye catches up with the story: it sees a coin sinking to the bottom and an isolated bubble or two floating to the surface.

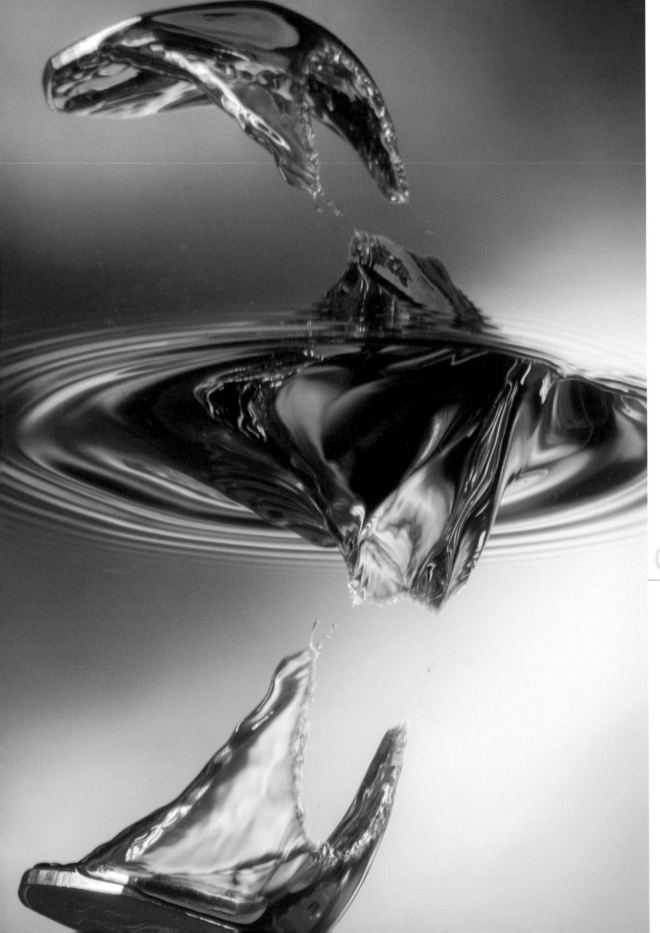

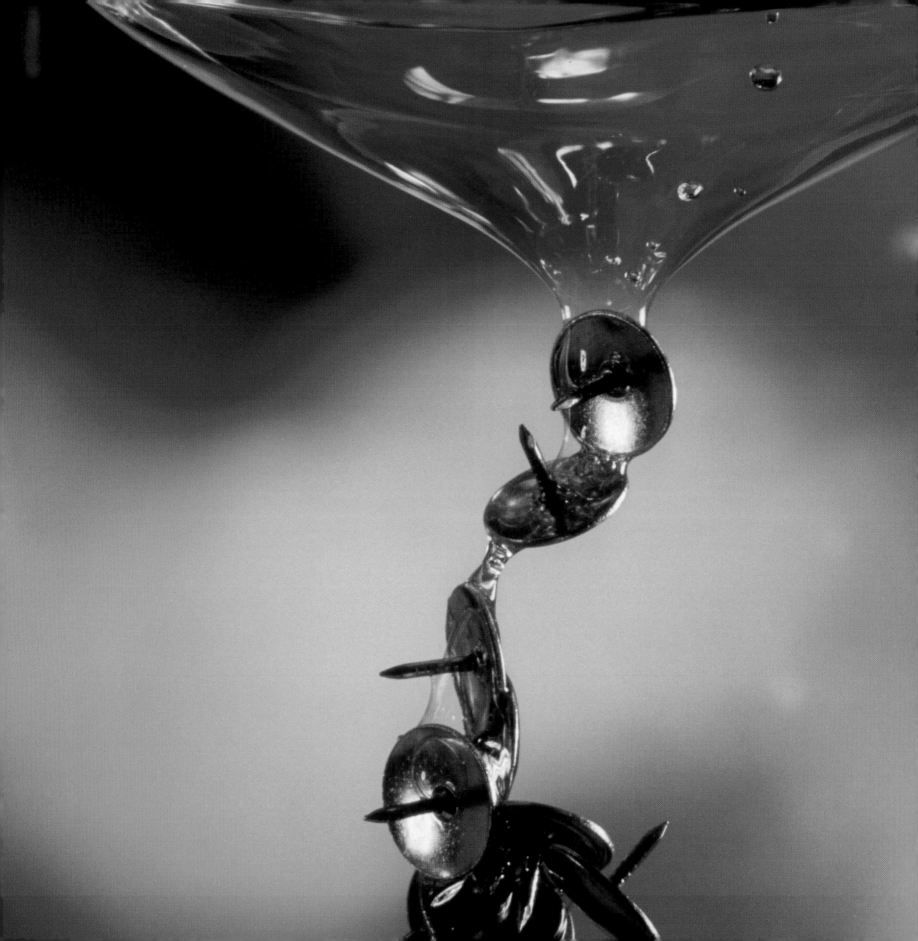

To investigate further, I wondered if the experiment could be refined by dropping objects through a film of soap. A soap film is a microscopically-thin sheet of water sandwiched between two layers of soap molecules. At about 1 micron (1/1000th mm) the sheet is far thinner than the diameter of a red blood corpuscle. Soap is composed of a long chain of polymer molecules which can coil and uncoil under tension and relaxation, and this gives the film its great elasticity. Bubbles and other kinds of films soon burst because the tiny amount of water contained in them quickly evaporates.

A soap film can be destroyed by a pinprick, yet here we see a succession of drawing pins falling through a film without breaking it. The tiniest hole in a film will burst it, so here the small bubbles attached to the pins offer a clue, and the high-speed photographs of a coin dropped through the film (overleaf) tell the story.

IN ORDER TO PASS THROUGH, AN OBJECT PULLS WITH IT A PIECE OF THE SURFACE

01

02

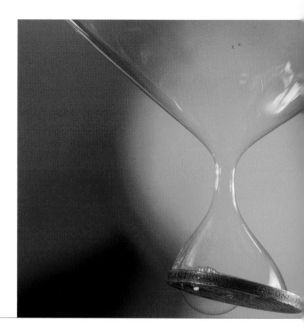

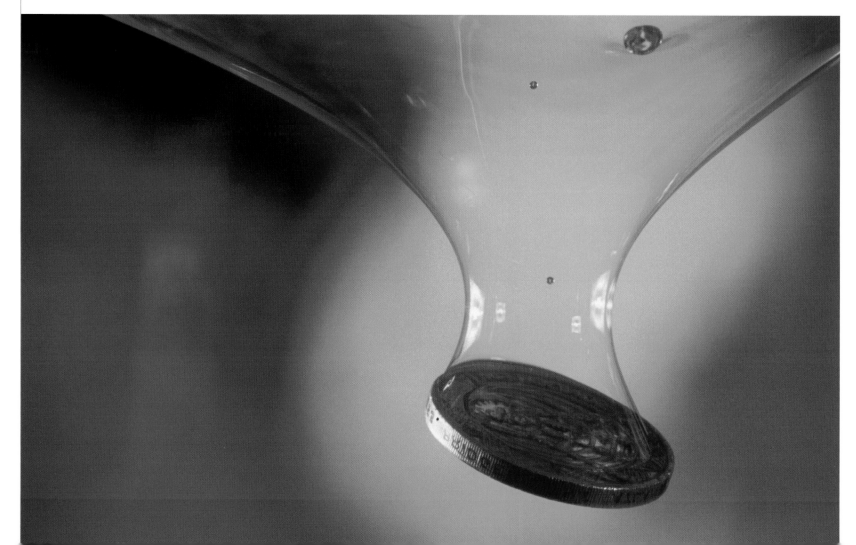

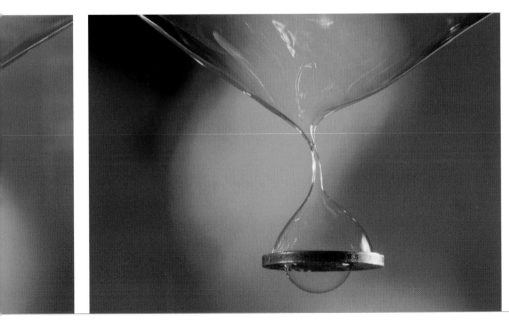

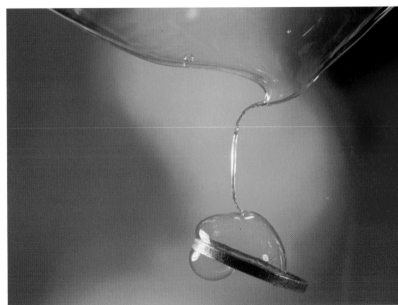

03 04

The process is similar to that involved when a coin is dropped into water. As we saw earlier, the coin pinches off a bubble of surface film but there is a difference: whereas a coin travelling upwards through a soap film would produce the same result but mirrored, a coin projected upwards out of the water leads to a dramatically different result, as we shall see. These images only touch the surface of a vast reservoir of possibilities, each of which may require its own simple 'tool' to bring it to life. But the first step is visualization, aided by patient observation. Simple everyday examples of things worth examining would be the spray from a peeled orange, the leaping of fat droplets from a frying pan and the individual droplets in a garden spray producing a rainbow in the sunlight.

As the coin drops it drags out a tube of film [**01**] that quickly narrows [**02**] and [**03**], and finally pinches off [**04**]. At this precise moment the film above is sealed and the coin below is wrapped in a bubble. The bubble is the coin's 'passport' to the other side and the whole process is remarkably similar to the mechanism known as 'pinocytosis' that cell membranes use to engulf small particles.

A film of soap has other remarkable qualities. We marvel at the kaleidoscopic colours of a soap bubble, but a film of soap suspended vertically on the other hand, shows parallel bands of colour. The bands owe their formation to light interference, and were studied by Isaac Newton during his fundamental investigations into the nature of light. Crucial to this process is the fact that the width of the film is comparable to the wavelength of light. White light consists of a range of different wavelengths covering the visible spectrum from red to violet. When light strikes the film at a certain angle the rays reflected from the two sides of the film interfere. The amount of interference depends on the exact wavelength and the thickness of the film. The film is not uniformly thick; thanks to gravity, the bottom of the film bulges slightly compared with the top, so in effect, the film has a wedge-shaped section. The vertical gradient in film thickness therefore produces a corresponding gradient in interference and the result is the vertical series of colour bands.

Shown here is the kaleidoscope of shape and colour that can be achieved by soap films, formed inside rolled-up sheets of celluloid. Each 'cell' of soap film was formed by dipping the tube into soap solution then holding it vertically for a short while to allow the cell to move down the tube under gravity. Repetition of this procedure allowed me to produce a stack of cells.

CRUCIAL TO THIS PROCESS IS
THAT THE WIDTH OF THE FILM
IS COMPARABLE TO THE
WAVELENGTH OF LIGHT

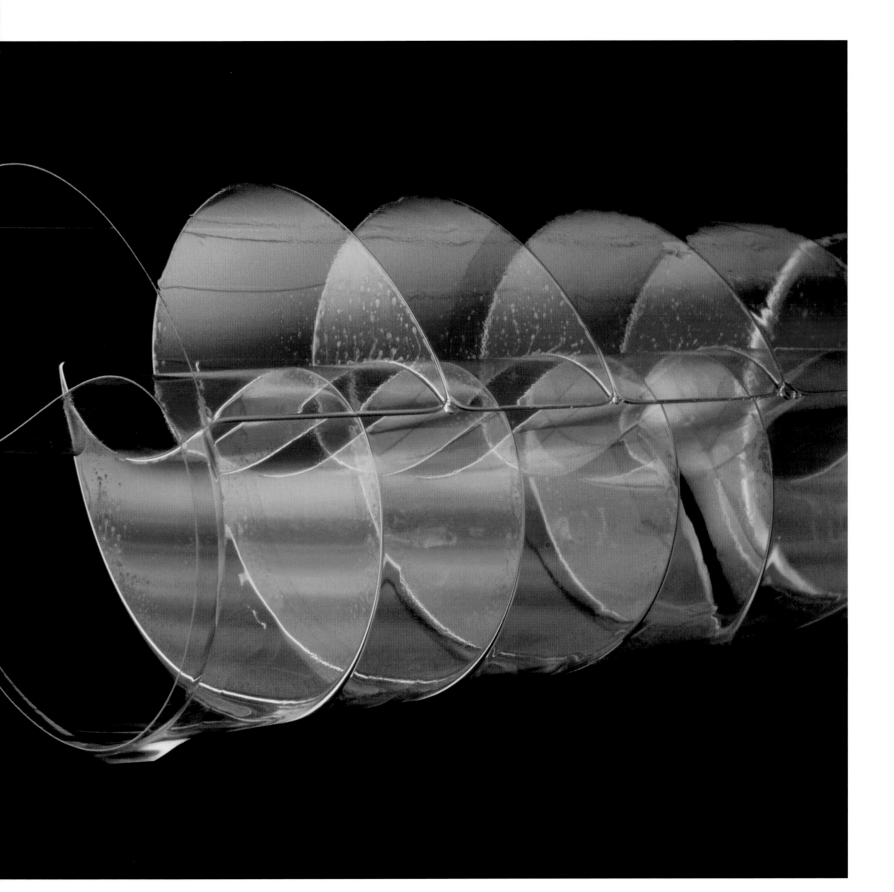

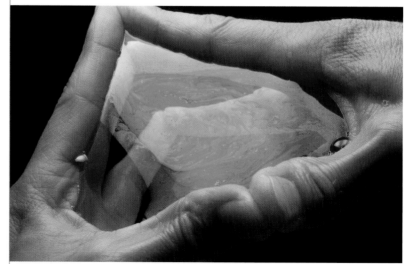

01

03

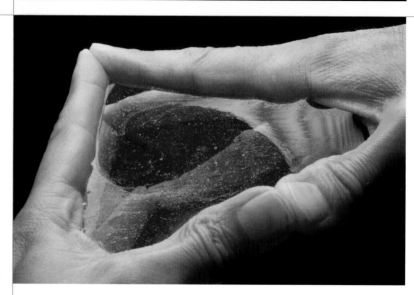

04

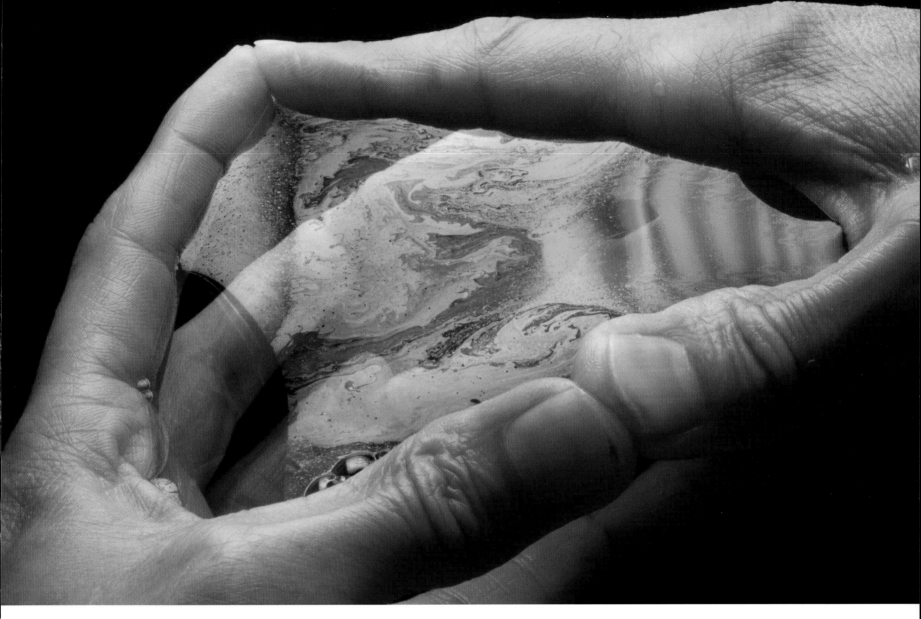

It is possible to keep a vertical soap film at more or less uniform thickness throughout its height by rhythmically stretching and extending it in your hands. Since the thickness gradient is now removed, the film experiences the same amount of interference throughout and a single colour comes to dominate. Moreover, since the film is continuously thinning due to evaporation, this dominant constantly shifts: one by one the colours of the spectrum take their turn. A compressed evolution, not of form, but of colour.

The swirling colours in a soap film are a familiar sight. Using a soap film mounted between my two hands we can see how, using gentle movements of the fingers and thumbs, the film can be made to progress through the colours of the spectrum from green to violet [**01–04**]. This all happens within the few seconds of the lifetime of the film .

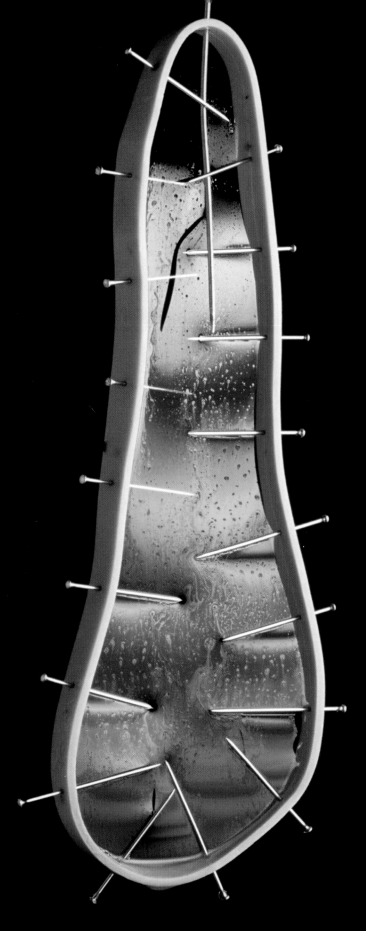

02

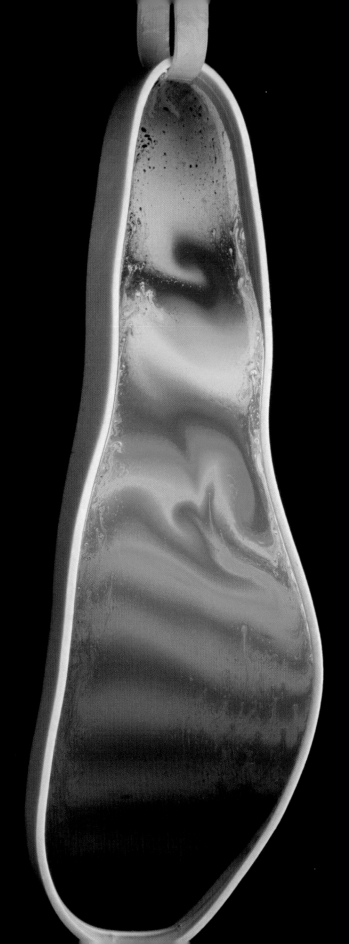

01

Although membranous structures such as soap films are unusual in the physical world, the living world is awash with them. In biology obvious examples are the 'birth' membranes of babies and new-born lambs, and the pericardial sac of the human heart. At another level, the bodies of single-celled organisms such as protozoans, bacteria and yeast are wrapped in a continuous protective membrane. To see the fundamental importance of membranes to life, we need to look through the electron microscope which reveals that the cell, and the various 'organelles' contained within it are built out of membranes stacked upon one another. Each membrane consists of a layer of hydrated lipid molecules, indeed not unlike a soap film itself. In Engineering the use of 'stressed' membranes is everywhere from the metal cladding of ships' hulls and aircraft fuselages to the much lighter materials deployed in hot-air balloons, parachutes, umbrellas and the inflatable rubber tyre.

Soap films can only exist within closed boundaries and are instantly destroyed by any tiny interruption in the boundary. In this case the film has been thrown on a boundary consisting of a rubber band [01] and again on the same band, this time perforated with dressmaker's pins [02]. The whole edifice is maintained in a delicate state of balance and will shatter at the slightest touch.

WHEN LIGHT STRIKES THE FILM
AT A CERTAIN ANGLE THE RAYS
REFLECTED FROM THE TWO
SIDES INTERFERE

04

03

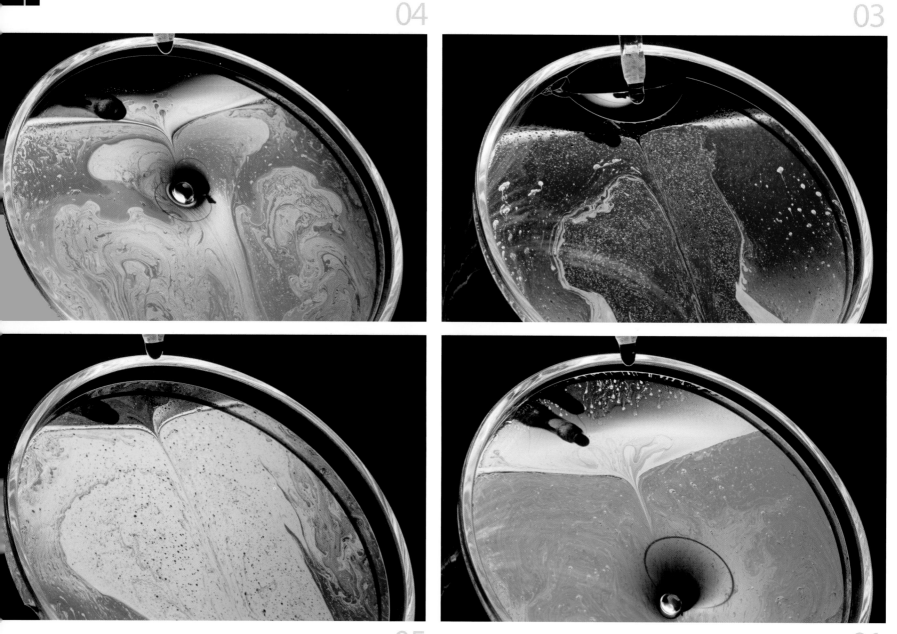

05

01

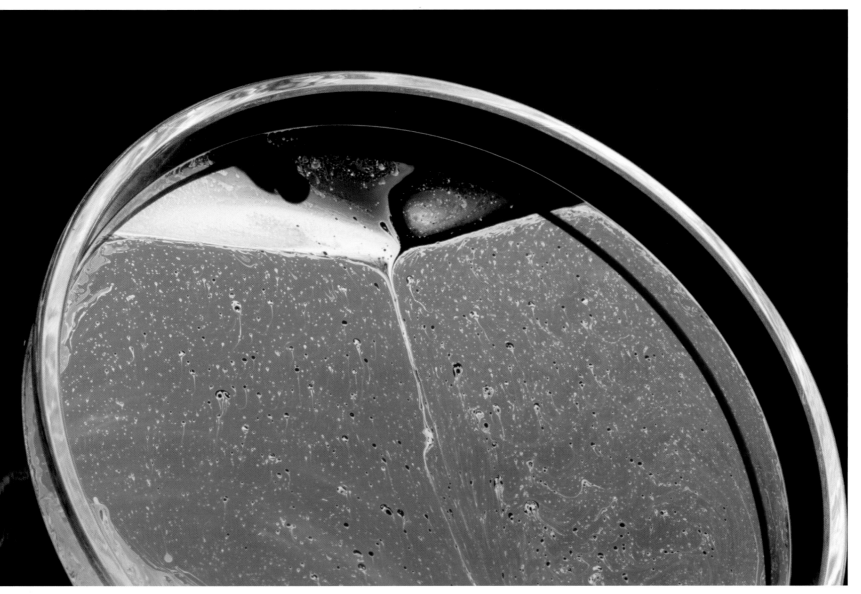

Next, I mounted a soap film over the mouth of a wine glass, orientated it slightly away from the vertical and dispensed a streamer of water from a burette onto it. Seeing the 'water trick' work for the first time was definitely something of a 'eureka' moment for me. It was entirely unexpected and as the rainbow changed before my eyes I could only smile and shake my head in wonder. It seems appropriate that this fugitive thing should only come to life through an accidental play of light. It is best to observe it in a dark interior with a light source held at an angle of about 45 degrees to the film.

In some pictures you can see the droplets bouncing down the film as though on a trampoline. The rivulet of droplets formed a line dividing the film and created a re-circulation of materials within the film. This has the effect of mixing the interference colours so that only a single dominant prevailed. Within seconds the dominant hue transformed through the various colours of the spectrum from green to violet [**01–04**], finally transforming to a kind of gold [**05**] before breaking.

01

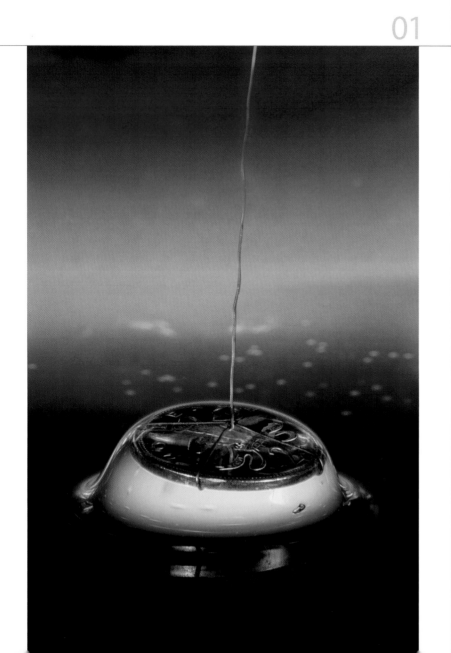

02

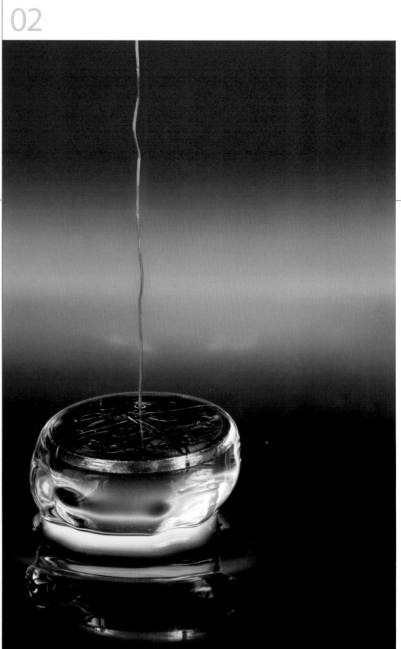

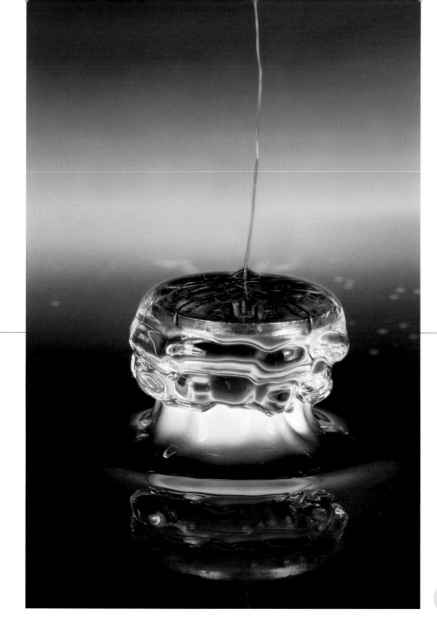

03

Unlike the soap film, an object breaking through the water's surface from beneath does not produce the same effect as an object passing the other way. The surface of water is a two-way barrier. In practice, most things penetrate it from above but there are occasions when movement takes place in the other direction (leaping fish, launching submarine missiles, surfacing whales etc.). I used a coin, pulled up from beneath to see what was happening and produced some surprising and beautiful results.

These photographs show the reverse of the coin-throwing experiment described earlier: pulling a submerged coin rapidly out of the water using a thin copper wire. The whole emersion sequence, lasting less than a fifth of a second, is a process of compressed evolution.

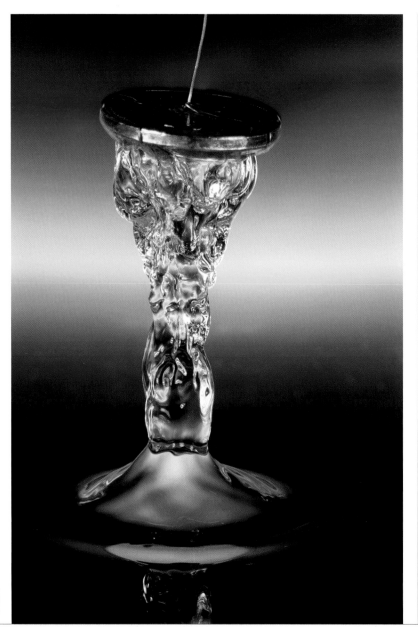

01

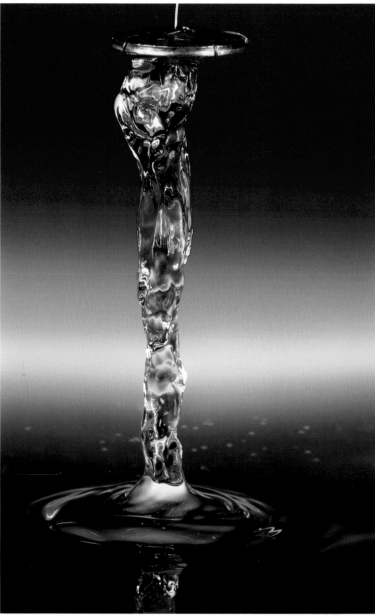

02

The coin is, in effect, being employed as a tool to create a kind of liquid sculpture, although the actual 'chiselling' process is down to nature itself through the intermediary of surface tension. As in any learning process, acquiring fluency in the use of the tool depended on constant feedback, in this case the innumerable individual photographs that failed to reveal anything unexpected. The secret lay in converting a tug into a very smooth, rapid movement.

The mound of water becomes drawn out like molten glass [**01**], first into a column and then into a narrow stilt upon which the coin appears to be balanced as though in defiance of gravity [**02**]. In its efforts to contain the water inside the ever-lengthening column, the surface film continuously remoulds itself into a series of diamond-like facets [**03**].

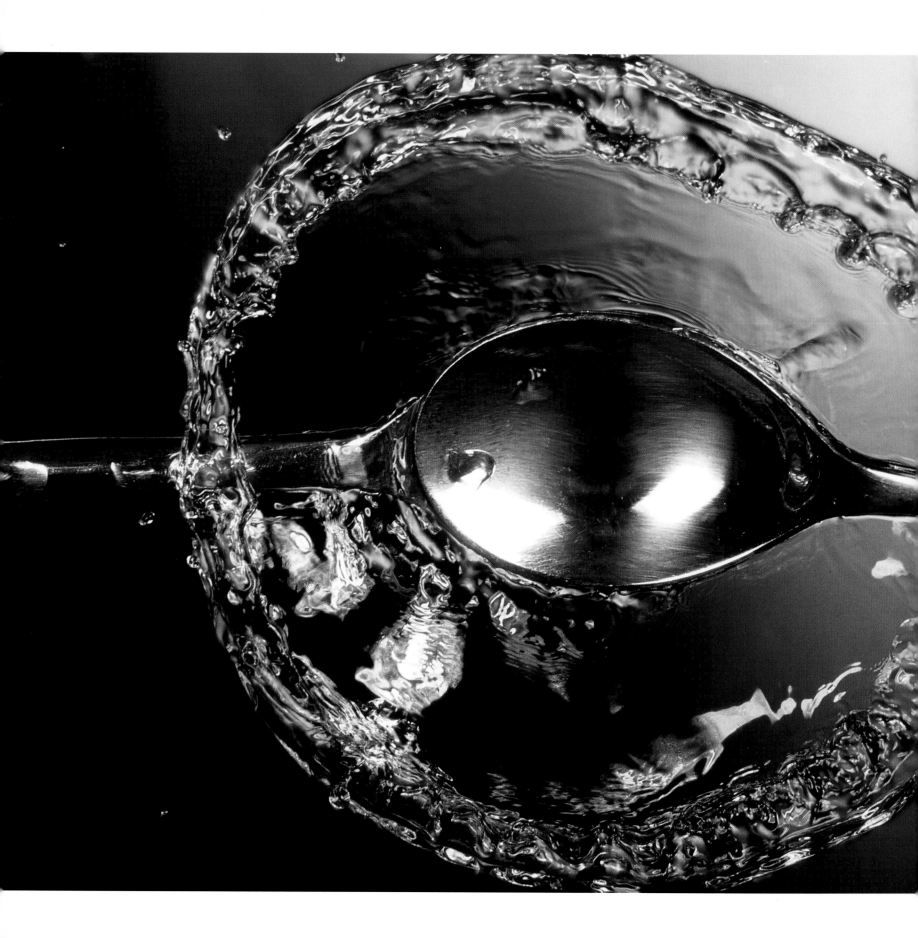

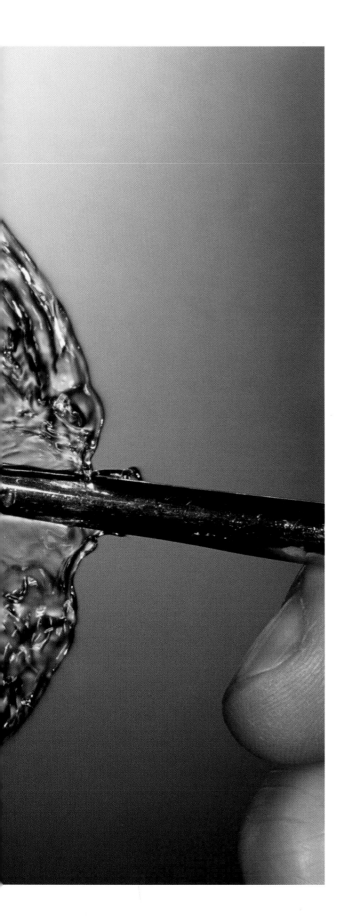

WHEN SEARCHING FOR AN ELUSIVE PHENOMENON, THE SIMPLER THE INSTRUMENT, THE MORE INTERESTING THE FINDINGS

Philosophers and scientists are fond of invoking Occam's Razor, otherwise known as the Law of Parsimony. According to this, when explaining something no more assumptions should be made than are necessary. In other words, keep explanations simple. The counterpart of this, when searching for an elusive phenomenon, is to try to keep the search tools as simple as possible. The simpler the instrument, quite often the more interesting the findings ... forcing water into thin sheets using some everyday objects threw up some of the most interesting and beautiful results.

Earlier photographs have shown water taking on 'plastic' forms whenever it is released from containment, including water forcing itself into micrometer-thin sheets, as shown here. A circular disc of water is forced out from between two teaspoons, one having been clapped down hard on top of the other.

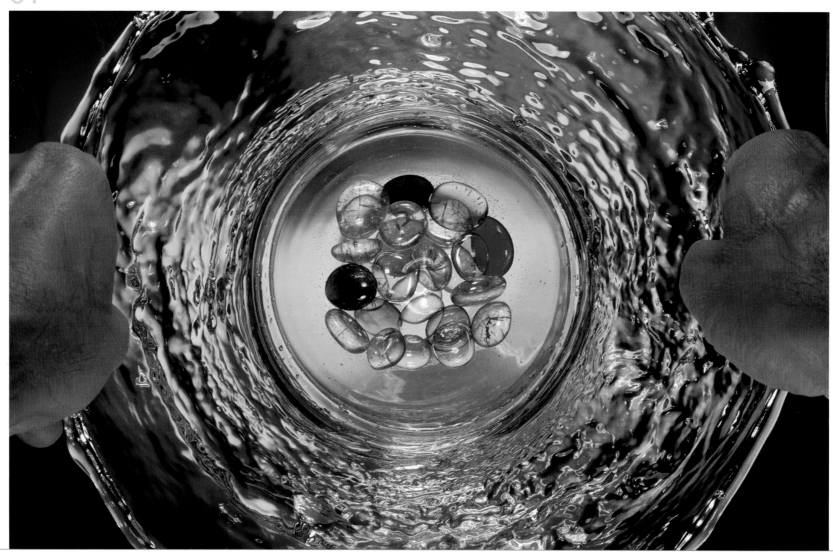

TIME IS NATURE'S WAY OF ENSURING THAT
EVERYTHING DOES NOT HAPPEN AT ONCE

Employing the same principle as the two spoons – forcing water into thin sheets – I began to drop objects into bowls of water, producing cones of water from around the perimeter. Observing these strange shapes emerging into the flashlight before me inevitably stimulates thoughts on that great conundrum – time. If, as is claimed, time is simply the stream that flows through events, this accords with my own favourite definition: time is nature's way of ensuring that everything does not happen at once.

While clapping two spoons together produces a flat disc of water, dropping one bowl on top of another identical one produces a conical sheet of water [**01**]. The lower bowl needs to be full to the brim with water for the demonstration to work properly. As the conical structure rises into the air its mouth eventually begins to extend outwards as a brim [**02**]. The glass beads are simply decorative.

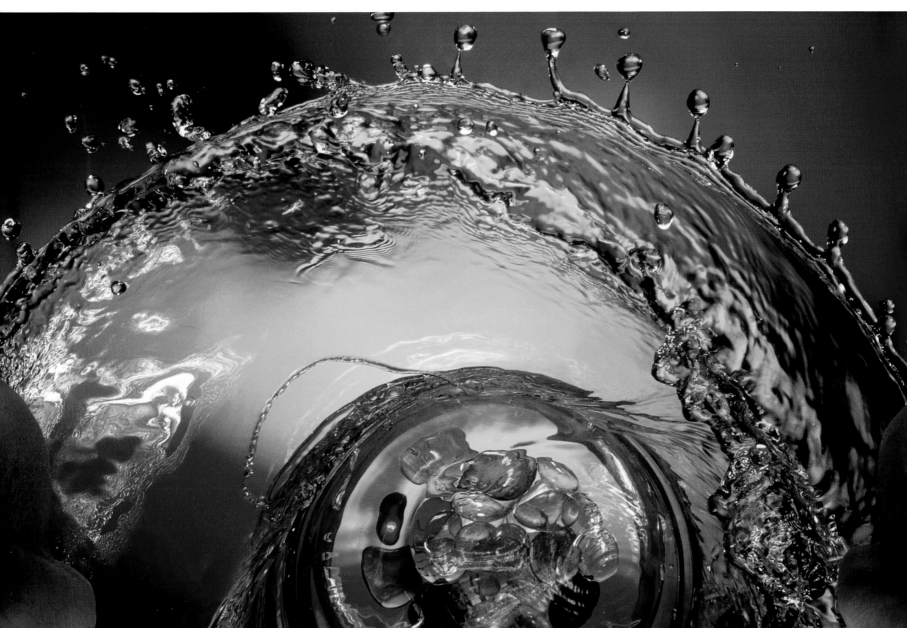

If the bowl can be dropped evenly, the water spouts up in a slender sheet all round the bowl, rising into a funnel and then, as gravity takes its toll, turning out a rim like an upturned sombrero with a layer of water detatching itself around the fringe. A fleeting form, made visible only by freezing time. Poets endeavour to escape the constraints of time by contrasting it with art, which is eternal. Hence Longfellow's 'Art is long, and Time is fleeting'. Whatever else art is, however, it is indisputably a product of the human mind and as such will endure only as long as consciousness endures. Likewise, knowledge is only a human commodity, prone to extinction as well as creation. My experiments have necessarily been limited by size, but would larger apparatus give the same result? Is the umbrella spray, with its bizarre form, dependent on scale? Might it be possible to create a man-sized, even house-sized, umbrella using sufficiently large materials? And how long would it last? Could we clearly see it with the naked eye? One thing is clear: if I were to progress to the next stage of the problem I would need a far larger space than the one currently available.

Ultimately the whole structure takes on the form of an inverted sombrero. Close inspection shows that there are in fact two separate sheets of water forming the sombrero – the outer one being a coronet-like fringe of detaching water droplets.

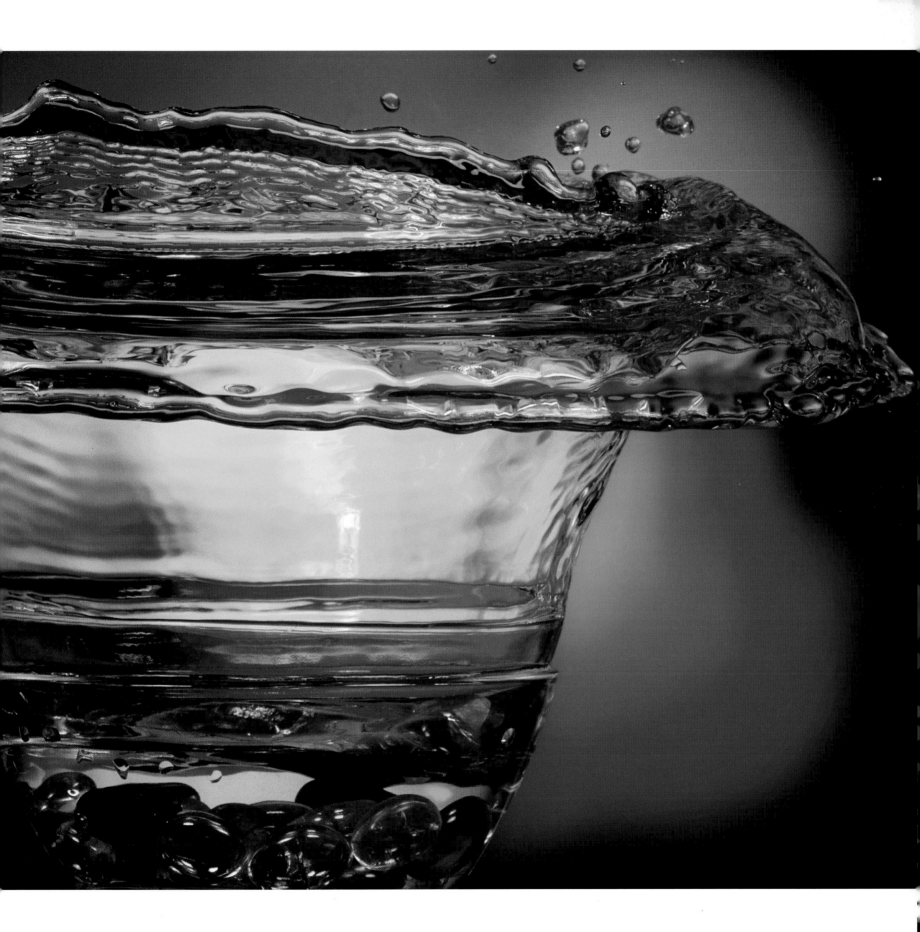

01

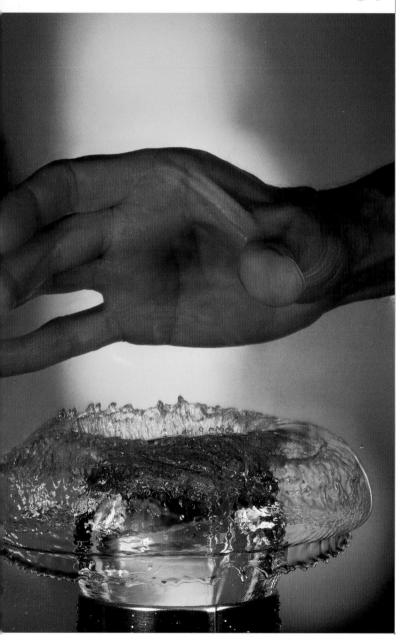

Dropping a ceramic globe into the mouth of a tin can brimming with water might not have been expected to produce a phenomenon new to fluid dynamics, but I think we may have one here. In earlier trials I learned that it was essential for the globe to be marginally wider than the mouth of the water container. This ensured that as the globe landed, the water was forced to escape through an ever-narrowing slit until the globe finally plugged the bowl completely.

01 captures a dome-shaped sheet-spray in an early stage of formation rising towards my hand which has just dropped the globe. By the stage shown in **02**, my hand has become enveloped inside the dome, and close inspection shows that its surface is peppered with concentric shock waves – miniature versions of the whirlpools sent out by pebbles dropped into a pond. Eventually these shock waves become perforation sites [**03**] which coalesce and bring the whole fragile structure clattering to the ground in a deluge of spray.

02

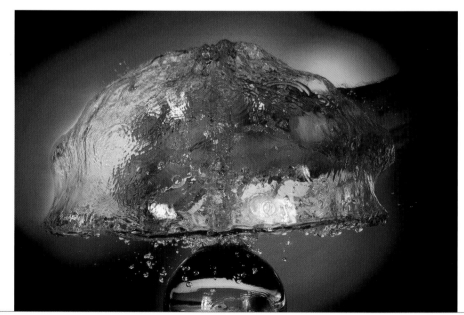

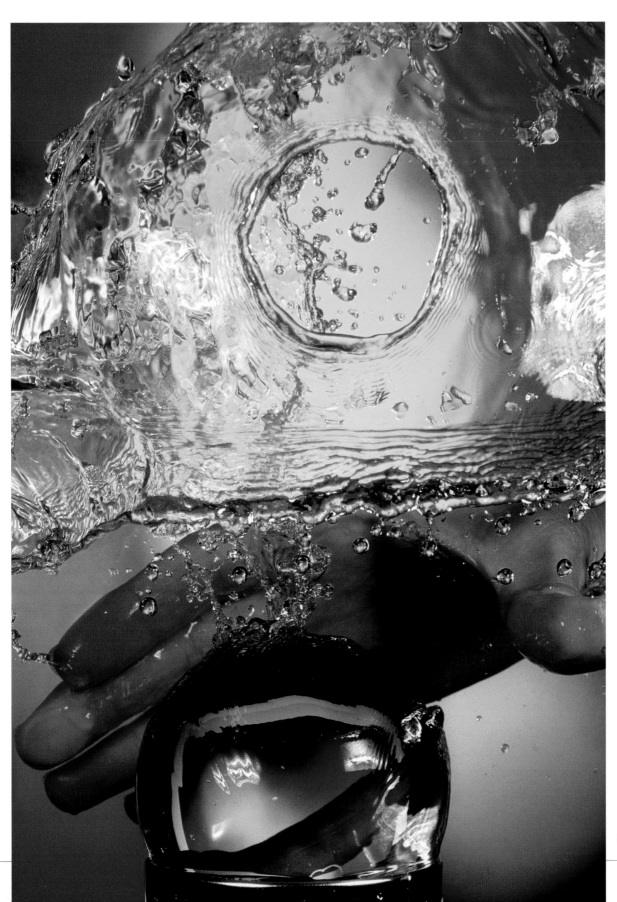

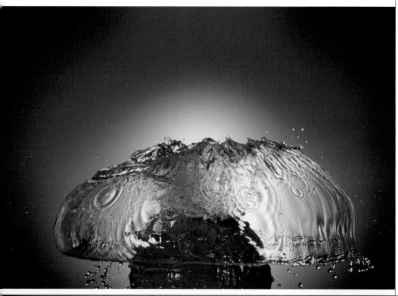

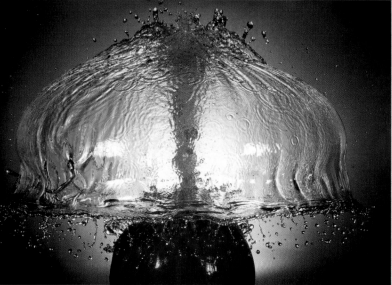

The water spouts up around the perimeter of the globe and sweeps its surface up almost invisibly, like a thin, moving skin. When it reaches the upper pole it rears up in a foaming column and spreads like an umbrella as it falls outwards and downwards. Looking at the pictures you would hardly know the skin is there, it is so thin. One has to wonder at the architectural complexity on display in such an apparently simple phenomenon and for a long while I puzzled over why the rising water clung to the globe. Then I realized that the force holding the water to the globe was its own viscosity.

The wave converges on the upper pole of the globe and from there rears up into a foaming column. On reaching the pole, the water moves outwards and downwards [**01**], finally achieving the mature umbrella-like form of the sheet [**02**]. The 'stem' of the umbrella can be clearly seen through the side. Images **03** and **04** show the umbrella in its penultimate stage of life: the mouth begins to contract inwards into a series of pleats and fissures which eventually perforate the sheet presaging its destruction.

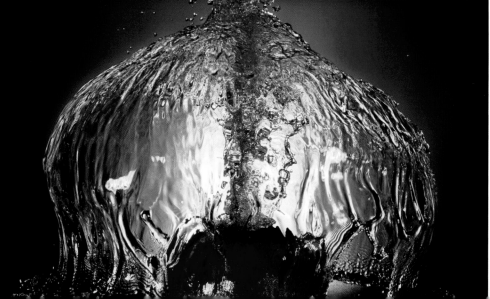

FLEETING EVENTS CAN BE CAPTURED AND PERUSED
AT LEISURE SO THAT THEIR BRIEF, HIGHLY COMPRESSED
EVOLUTIONS BECOME CLEAR FOR ALL TO SEE.

02

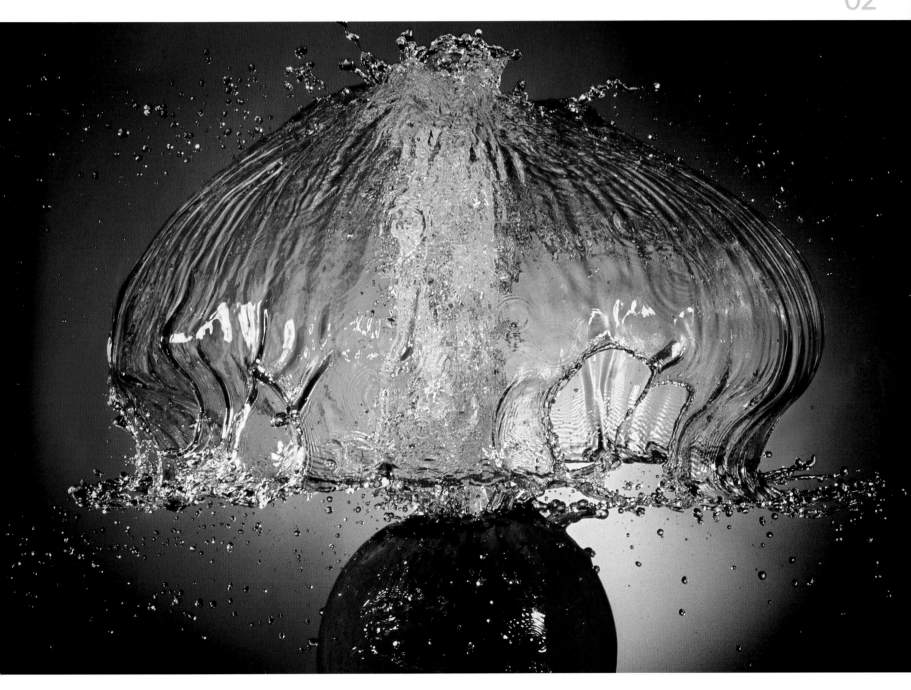

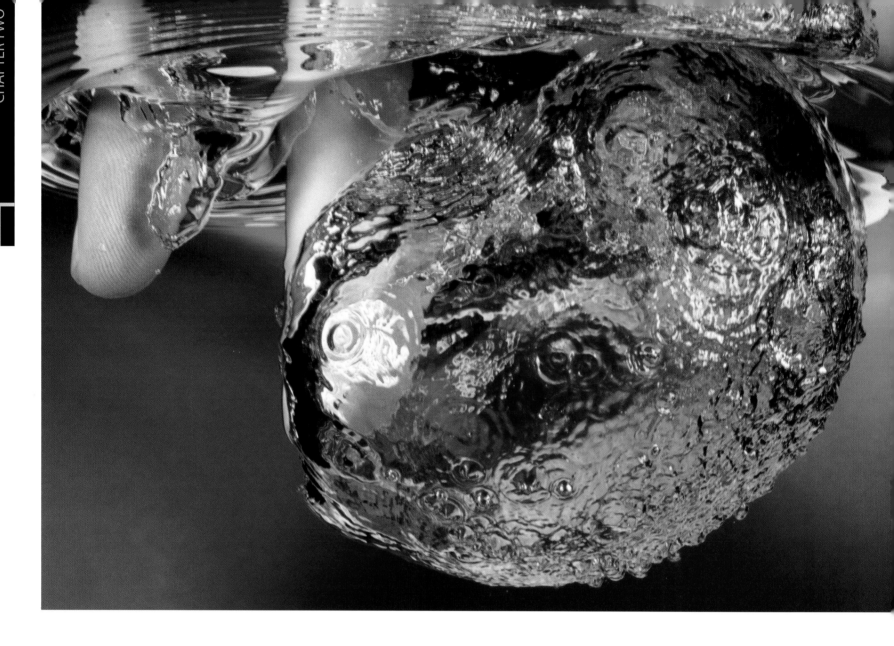

The 'sombrero' and 'umbrella' sheet sprays are, in effect, giant bubbles with a hole at one end. The seething activity in the surfaces of the sheets resembles the swirling images reflected in the surfaces of soap bubbles, and they are created by the same force: surface tension. For comparison, I devised ways of investigating real underwater bubbles. The first involved flicking my finger into a water surface to produce a lozenge-shaped bubble. As you can see, the bubble has a lunar-like surface, pitted with shock waves in the form of craters and whirlpools.

This demonstration [01] was not quite as straightforward as it seems – simply extending a single finger as fast as you can does not produce sufficient speed to result in cavitation. Whenever we flick our finger, using index finger tensed against thumb, we make use of a phenomenon known in the science of biomechanics as a 'catapult' mechanism. Energy stored in the tendons and muscles of the digits is suddenly released in a high-speed acceleration of the finger. 02 is a bubble rising from a ceramic container. A balloon housed inside the container has just been burst with a pin.

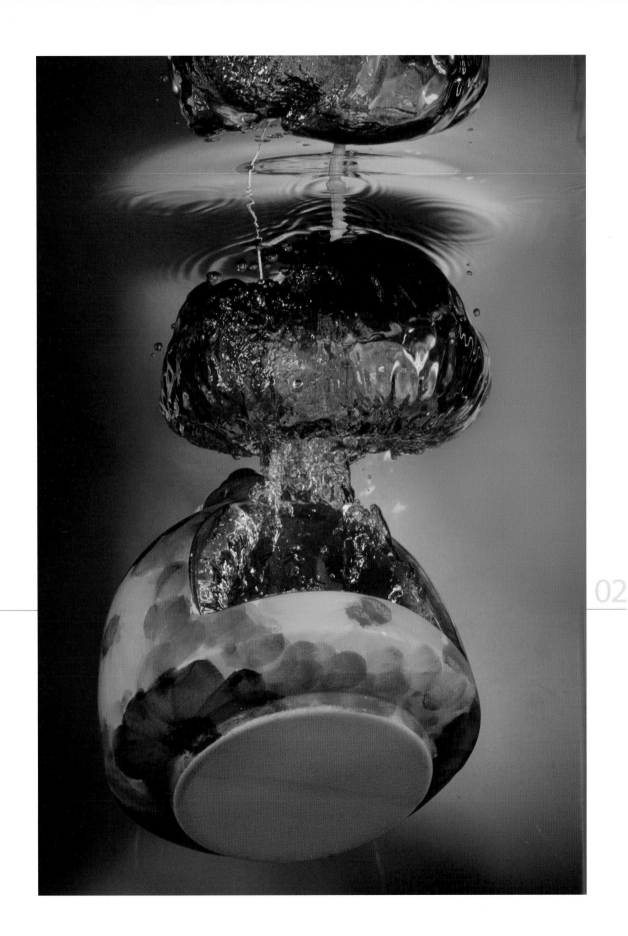

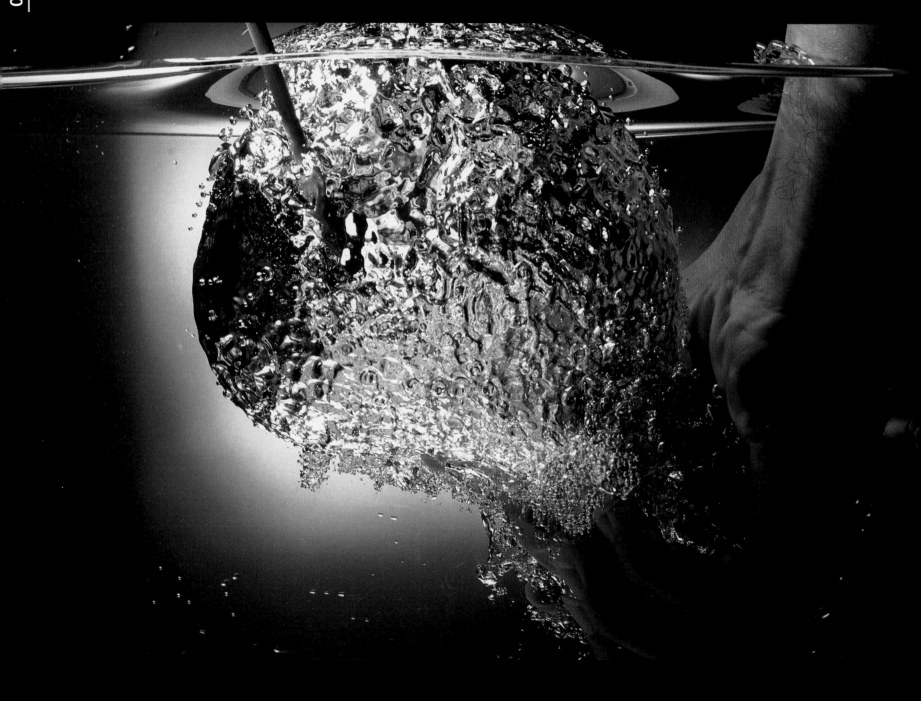

Bursting a balloon in an aquarium is probably the safest way of creating an underwater explosion. The ball of pressurized air, suddenly released from its elastic envelope, expands against the surrounding water producing a shock wave heard as a muffled bang. The gunshot crack of a balloon bursting in the air is also a shock wave, this time louder because the pressurized air expands more rapidly against the air in the atmosphere. A balloon inflated with water will not burst with a bang because water is virtually incompressible.

This is a more informative picture of a 'hand-held' bubble pushing up towards the surface of the water. The rubber skin of the balloon has completely withdrawn – this happens within a millisecond or two of bursting – revealing a silvery surface full of dimples, resembling a foil-wrapped golf-ball. The hillock of water heaved up above the balloon is alarmingly reminiscent of a tidal wave forming above a rapidly up-thrusting ocean floor.

A BALLOON INFLATED WITH
WATER WILL NOT BURST WITH
A BANG BECAUSE WATER IS
VIRTUALLY INCOMPRESSIBLE

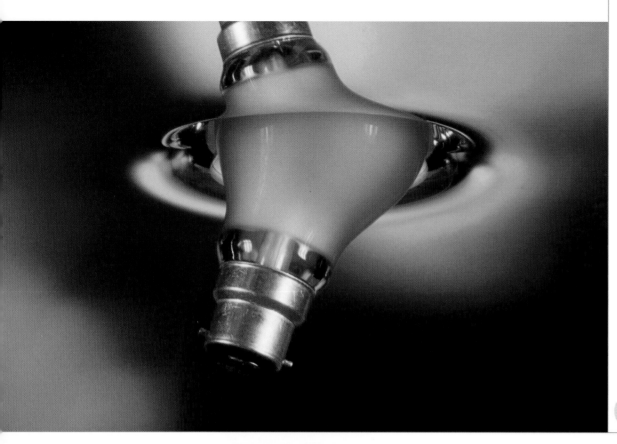

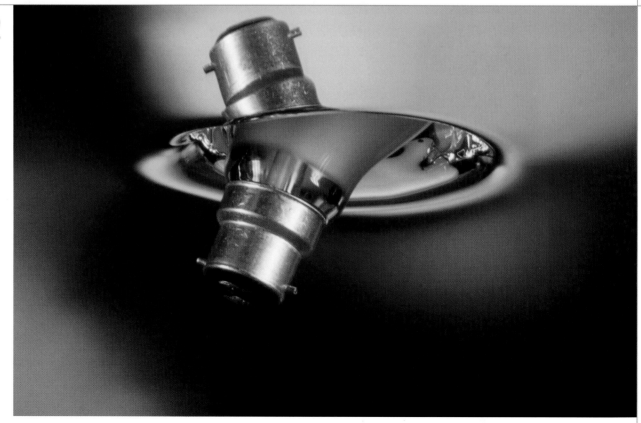

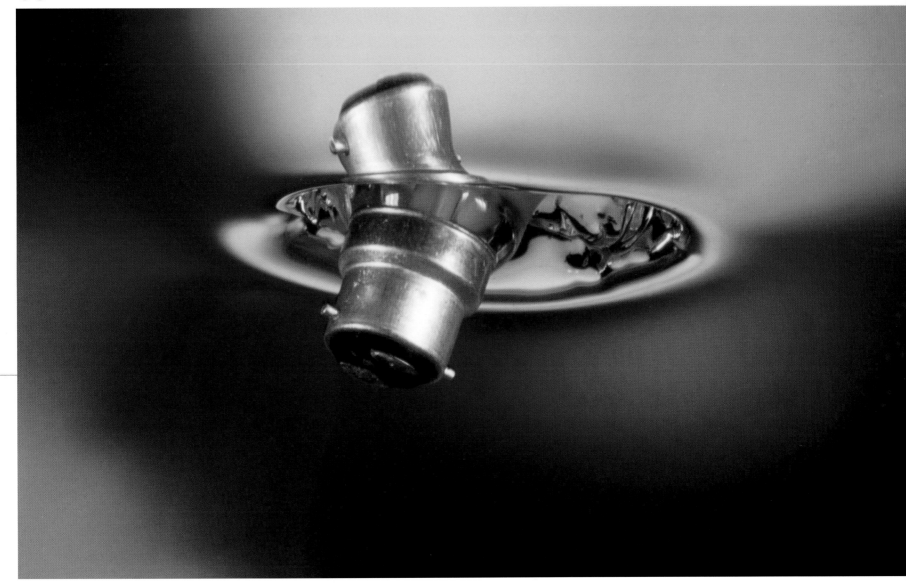

The balloon experiment showed that, for a split second at least, water can behave like a solid object capable of being pushed up bodily from below by a sudden force. My next bubble did not have to be created because it already existed: an ordinary domestic lightbulb.

The reader would be surprised at the speed with which such a bulb races to the surface when released from thirty-odd centimetres below the water. These images, taken from beneath the surface, show a reconstructed sequence of three stages in the disappearance of the bulb into what look like worm-holes in space in the surface of the water. These structures are in fact the base of a mound of water heaved up ahead of the bulb and through which it has to pass in order to exit from the surface.

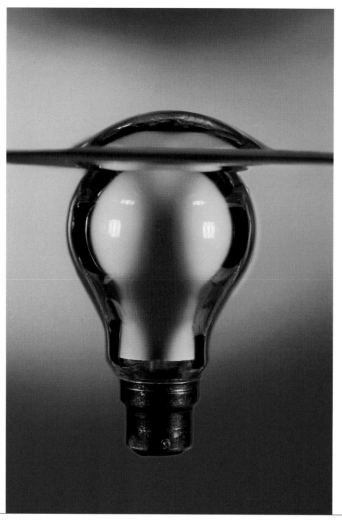

01

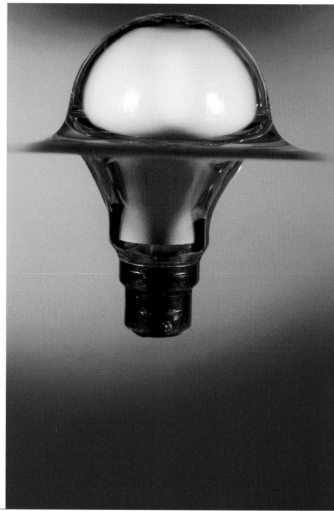

02

The lightbulb, when immersed, races to the surface in obedience to Archimedes' Principle, which as virtually every schoolchild is taught, states that the upward force on a submerged body is equal to the volume of water displaced. The speed of ascent of the lightbulb is helped by its smooth streamlined form. The resistance of an air bubble moving upwards through the water is proportional to its surface area, whereas the force on the bubble is proportional to its volume. So its speed of ascent must be proportional to volume/area i.e. its diameter. This accounts for the common observation that small bubbles rise to the surface more slowly than larger ones.

These side-views, again a reconstructed sequence, show what is happening as the light bulb hits the surface. First, a mound of water forms ahead of the bulb like a pressure wave [**01**] . The bulb then begins to pierce through the mound [**02**] eventually shedding the water in its wake [**03**, and **04** overleaf].

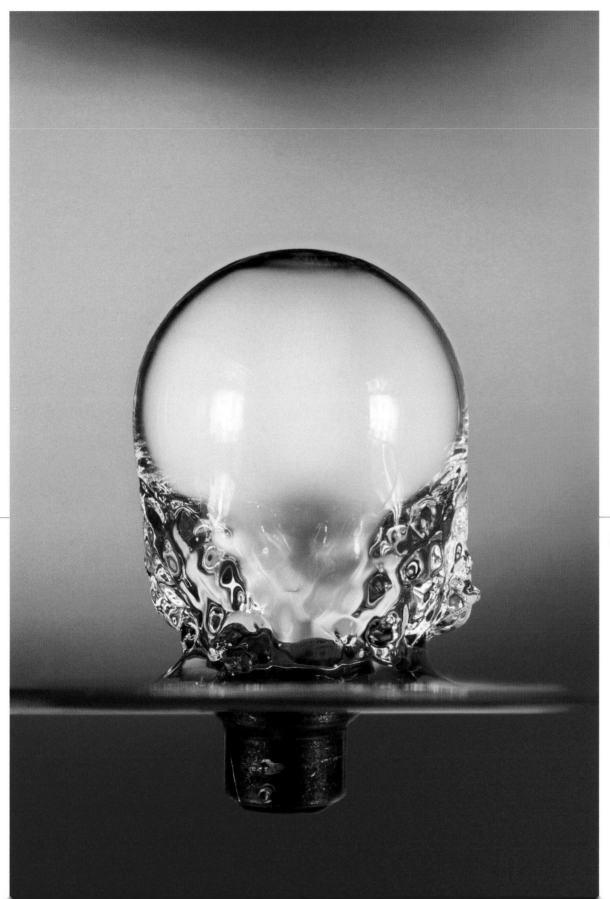

As it approaches the surface of the water the bulb heaves up ahead of it a mound of water. It is the perimeter of this mound which, viewed from below, produces the wormhole appearance. Next the bulb begins to pierce the mound as it emerges from the water. Once it has emerged beyond its widest point the water begins to detach as a turbulent wake. There is a brief point of transition where surface tension dissects the surface of the wake into an ordered series of facets reminiscent of those shown in the pulled coin experiment. The extraordinary jewel-like quality of the water as it breaks from a smooth surface to a turbulent mesh is just one more example of a wonderful natural form, usually concealed from us by time.

THIS ACCOUNTS FOR THE COMMON OBSERVATION THAT SMALL BUBBLES RISE TO THE SURFACE MORE SLOWLY THAN LARGER ONES

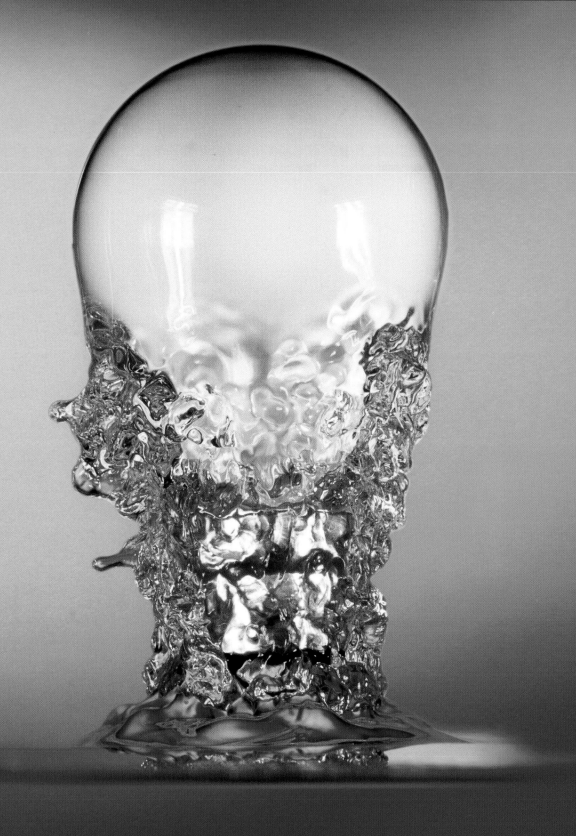

CHAPTER THREE
ALTERNATIVE VIEWS

At one time or another most of us have tried to imagine what it would be like to lose one of our primary senses: sight, hearing, touch or smell. We imagine a world of total silence, or one in which food has no taste, and everything is black. But these are probably misconceptions; if a sense is not there, if it is absent from birth, there can be no awareness of its absence, except by comparing oneself to other people. Many animals possess senses that humans do not have, but we do not feel that an experience is missing from our lives. We cannot imagine, nor miss, the sensation of the earth's magnetic field on a bird, nor the feel of low frequency sounds on our skin, as is felt by some fish. Wanting to experience the sensory world of another animal is purely aesthetic: it might enlarge our own visual experience. The same visual canvas that we see stretched before our eyes each day is perceived, explored and exploited by other pairs of eyes too. In this chapter, I invite you to see the world through new eyes; to observe the horizon through a screen of toadstools and grass stems.

There is no definitive visual experience of the world. It alters in the way it is perceived dependent on the lens through which it is viewed. But what is a lens? It is normally defined as a smooth, biconvex disc focusing light into an image on a flat surface. But any smooth, polished object can act like a lens, either refracting the light if it is transparent or reflecting it like a mirror if it is opaque.

The silver spoons [01] are behaving as concave mirror lenses reflecting the interior of a conservatory. The polished pebble [02] is reflecting the interior of a wire plant pot.

01

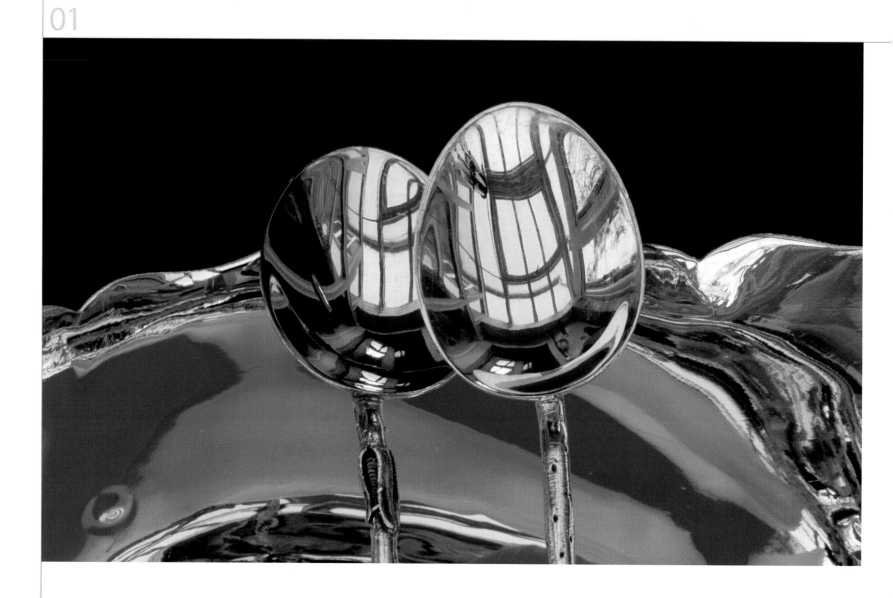

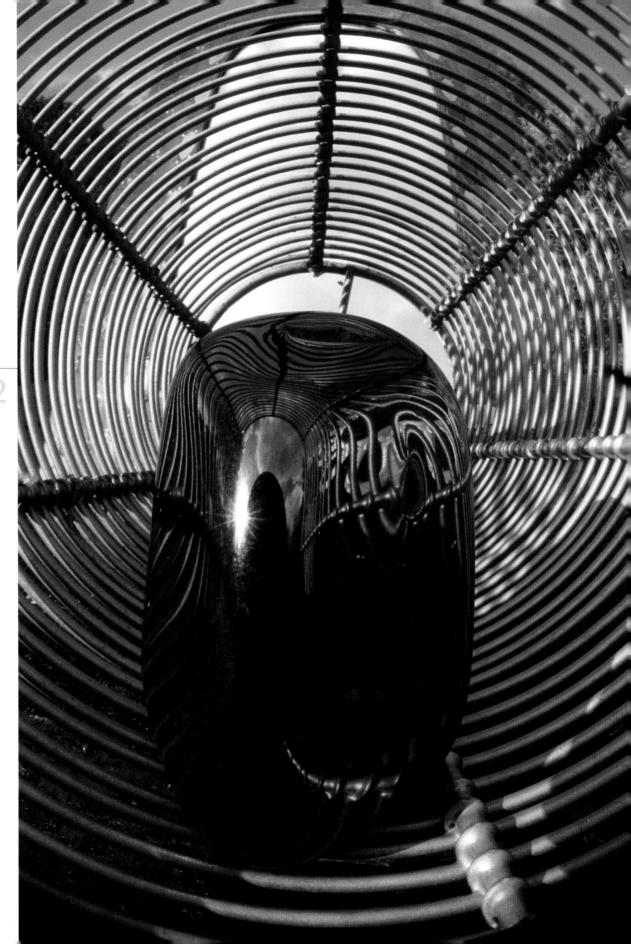

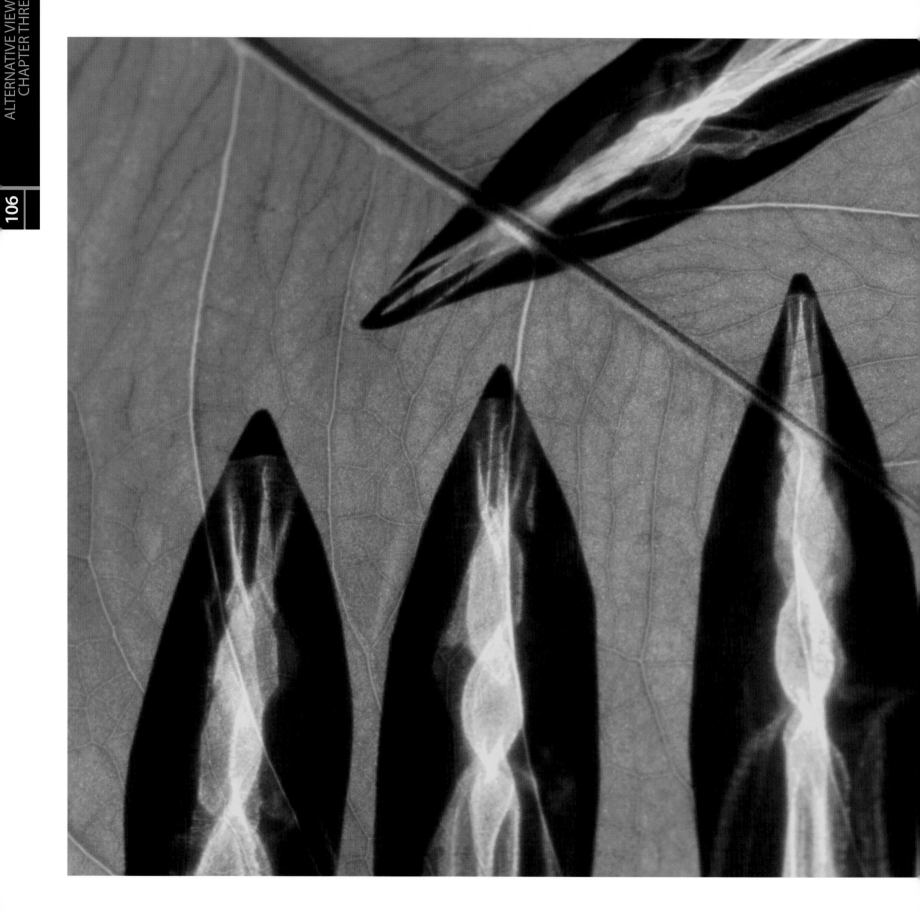

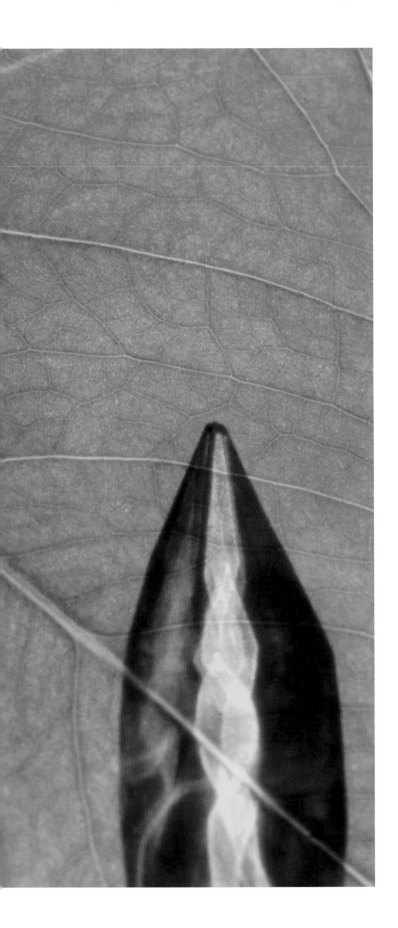

Most eyes, including the very simple eyes of snails and flatworms for example, use some kind of transparent lens to focus the light onto a retina. In theory, there are many different lens models available. A glass tear-drop, for example, of the kind found in elaborate chandeliers, can concentrate light along a line in its interior.

In this image, five glass teardrops have been arranged so that a silhouette of their images forms on a leaf-blade back-lit by the sun. As you can see, all the light has been concentrated inside the lens. Clearly this is one particular model that nature could never have developed for practical biological use since it could only have worked if the retina was placed inside the lens itself.

THERE IS NO DEFINITIVE
VISUAL EXPERIENCE
OF THE WORLD

01

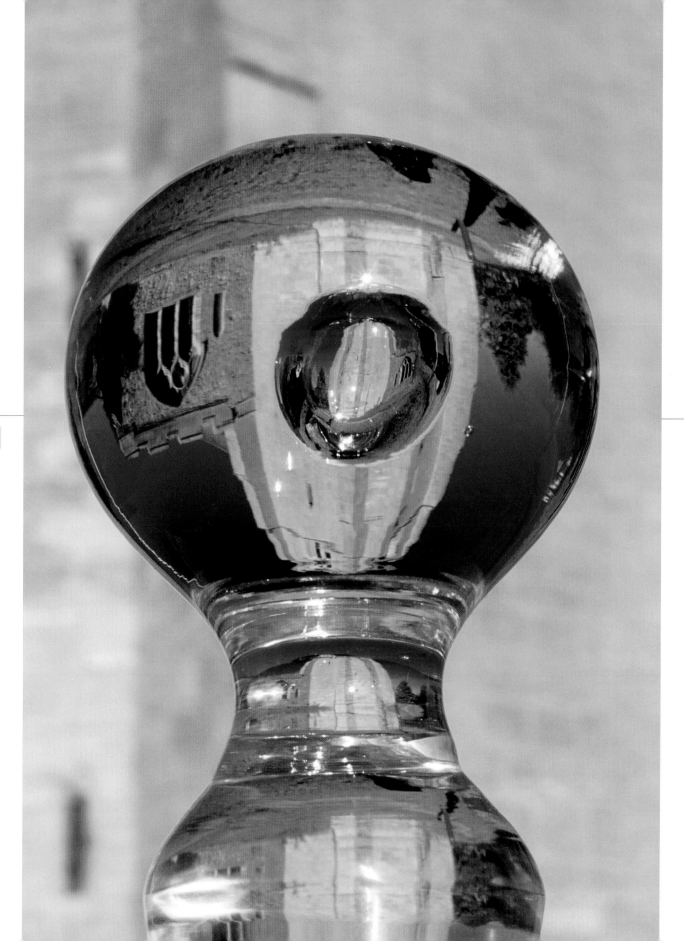

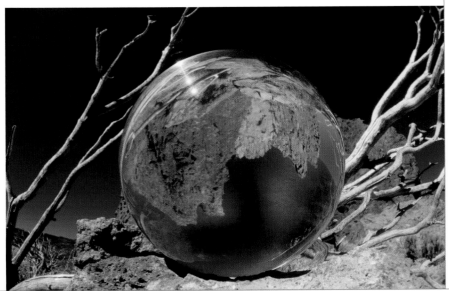 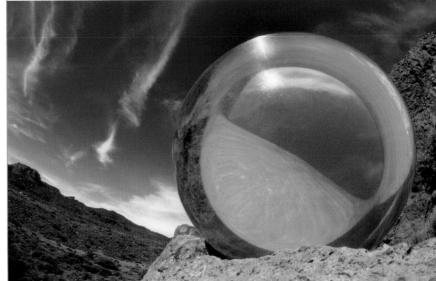

The eyes of animals have to perform radically differently to those of humans. A spider sights its prey with great precision using a telescopic eye, and the visual system of a nocturnal scorpion is so sensitive that it is blinded by the full moon. Whilst the human eye contains three visual pigments for colour vision, the butterfly boasts five. It also sees beyond the violet end of the light spectrum, into the ultraviolet. However, none of these animals has anything like the resolution of human eyes. Since they are largely uninterested in tiny details of form this is no disadvantage.

A glass sphere can be used as a powerful lens, focussing light from a very wide angle all around it: the church image in this glass stopper [**01**] was only a few metres away. And the mountain scene showing through the glass sphere [**02**] stretched over almost half of the horizon. But the main drawback with a spherical lens is the way it distorts the image, particularly in close-range focussing. You may be surprised to learn that the signet-ring shape [**03**] was produced by placing an orange behind the sphere!

A GLASS SPHERE CAN BE USED AS A POWERFUL LENS, FOCUSSING LIGHT FROM A VERY WIDE ANGLE ALL AROUND IT

Some animals have radically different fields of view to our own, the eye of a locust for example forms a dome-like surface studded with a multitude of tiny individual lenses, each of which contributes a single dot or pixel to the complete image mosaic seen by the insect. The dome-like shape of the eye means that the constituent lenses sample light from over a very wide angle – almost a hemisphere – giving the insect 'wrap-round' vision.

Although this lens collects light from a very wide section of the sky the 'hot spot' is actually an extremely concentrated image of the sun's disc. Focusing the sun's rays onto a match to ignite it demonstrates the power of a spherical lens.

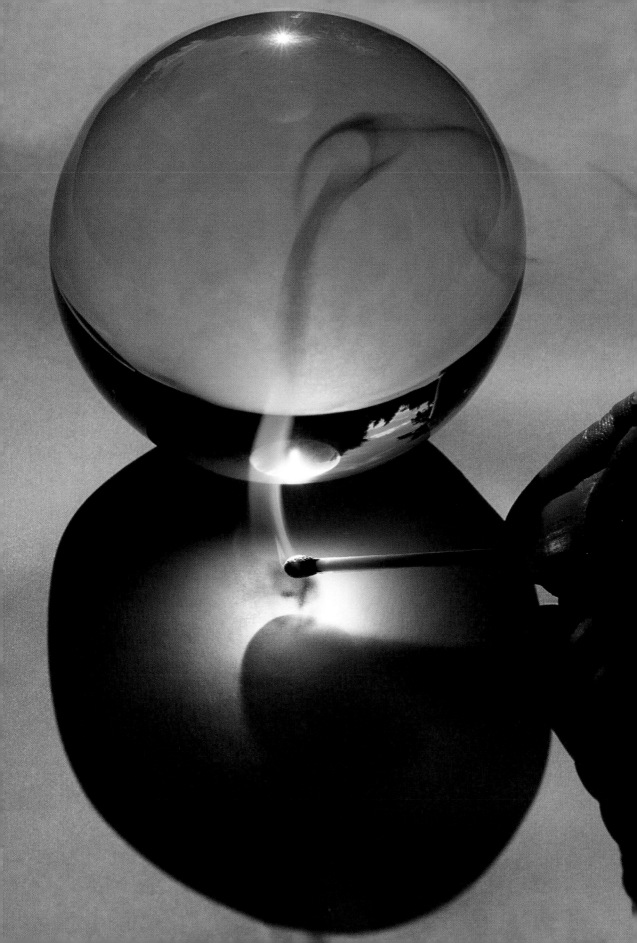

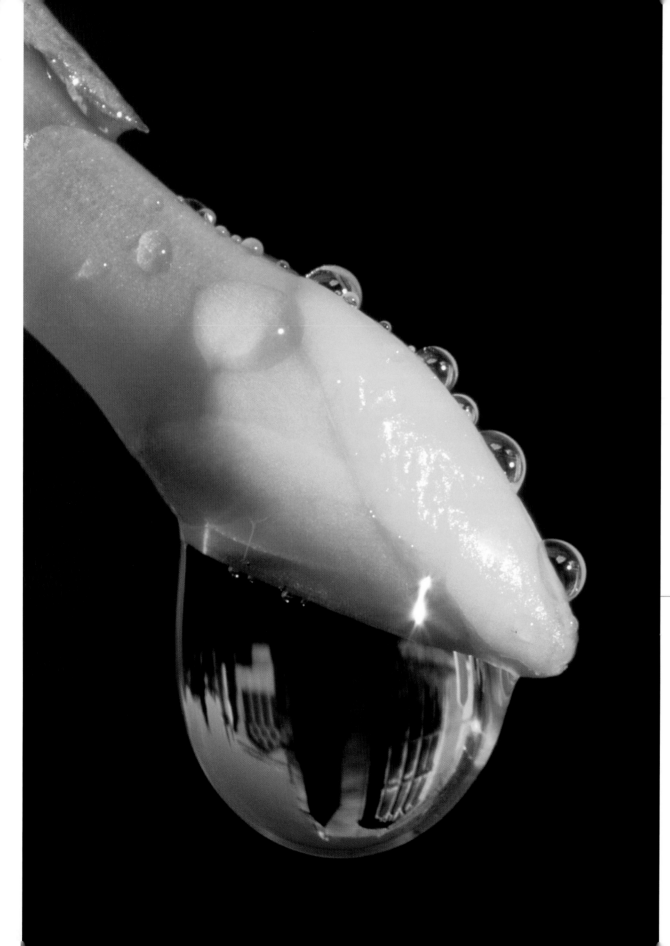

01

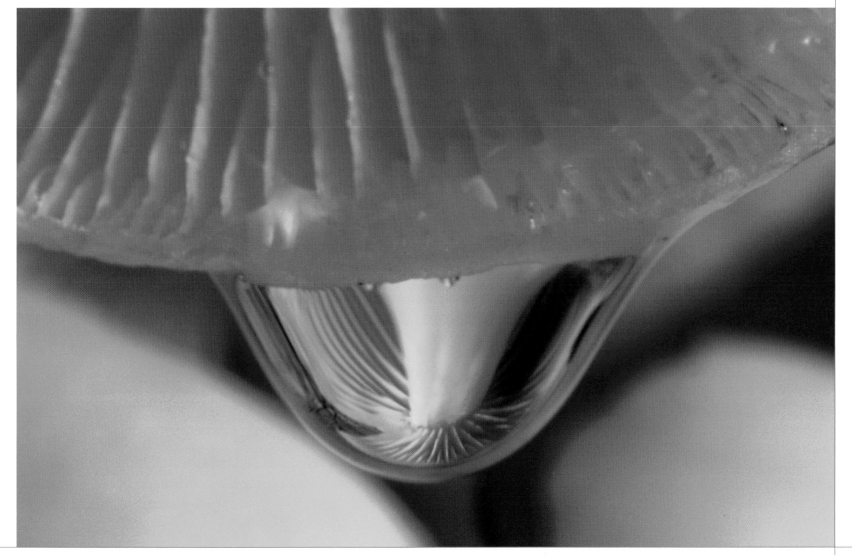

A raindrop is perhaps the commonest example of a natural wide-angle lens. In fact, because it has such an extremely small focal length it can act as a close-up lens and a landscape lens at the same time. As with most lenses, the resulting image is inverted. Animal eyes usually contain a biconvex (mammals and birds) or a spherical (fish) lens which also inverts the image on the retina. It is then the job of the brain to reverse it and align perception with reality.

Illustrated here are examples of raindrops acting as lenses on a jasmine flower bud [**01**] and a toadstool [**02**].

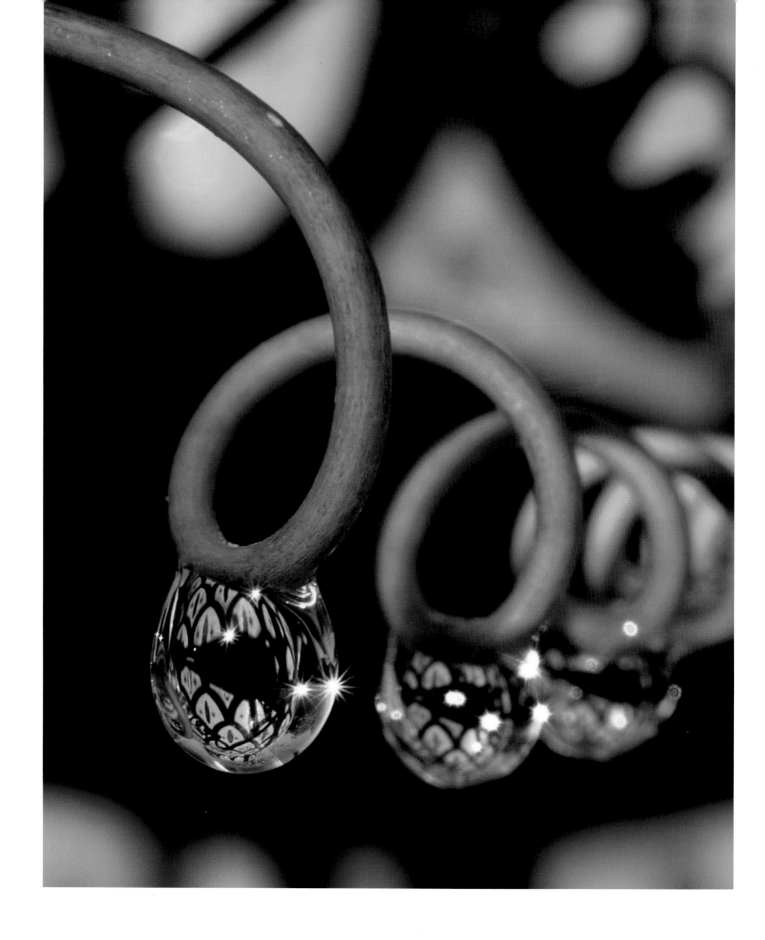

Some animals can actively adjust their eyes for close-up or distant vision, a process known as accommodation. Fish can focus on near subjects by moving the lens closer to the retina, although a commoner technique is to change the shape and focal length of the lens using a ring of tiny muscles attached to its periphery. This is the method that humans use and, as is well known, eventual weakening of the muscles due to eye strain or old age can result in the need for 'reading glasses'. Most invertebrate animals – i.e. animals without backbones – cannot accommodate this technique, but their eyes are so small that they have no difficulty in seeing close up objects anyway.

To demonstrate the optical properties of these rain droplets on a passionflower tendril, a large vase was placed a few centimetres behind it. You can see an image not only of the vase itself, but also the wider setting of the garden and sky behind it.

BECAUSE IT HAS SUCH AN EXTREMELY SMALL FOCAL LENGTH, A RAINDROP CAN ACT AS A CLOSE-UP LENS AND A LANDSCAPE LENS AT THE SAME TIME

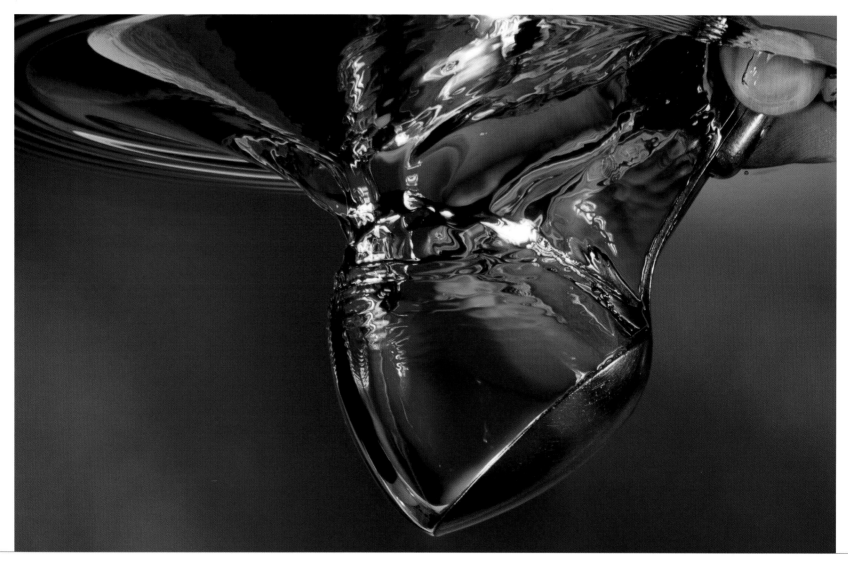

01

THE VISION THROUGH AN EYE WITH A
VERY SMALL FOCAL LENGTH SHOULD
HAVE IMMENSE DEPTH OF FOCUS AS
WELL AS WIDTH OF FIELD

The atmosphere itself can behave like a lens altering or distorting images. Good examples are the classic desert 'mirage' and the curious egg shape taken on by the sun as it sets upon the horizon. Both of these are due to fluctuations in the density of the air caused by the heat. Raindrops and globes present us with examples of refracting lenses made out of solid materials (water and glass), but there is also an example of a spherical lens made out of air: an underwater bubble.

The bubble shown in **01** was made by plunging a spoon through the surface of the water, with a lifetime measurable in milliseconds. An end-on view of the bubble [**02**] allows us to peer through it and see a shrunken image of the spoon, indicating that it is behaving like a wide-angled lens.

02

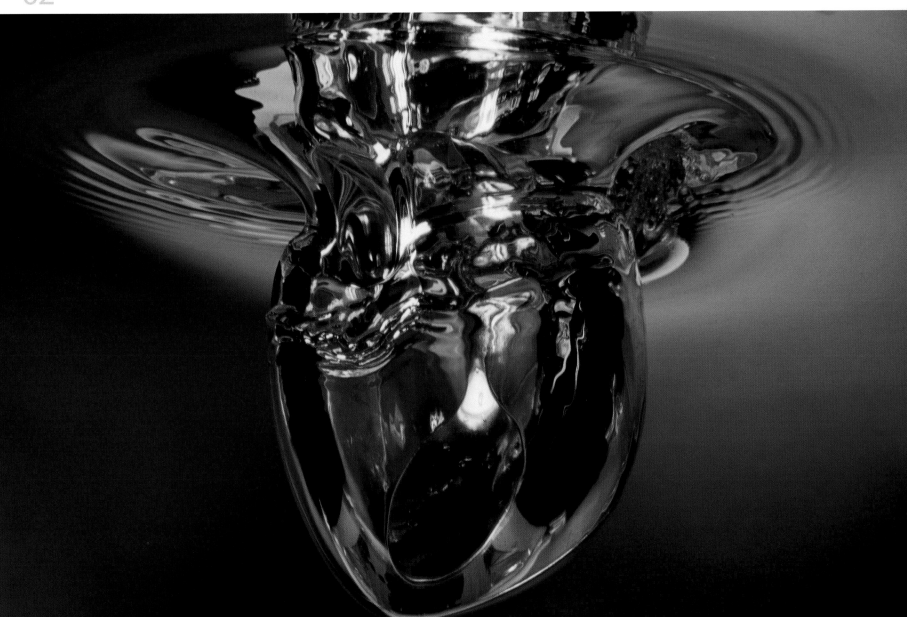

The eyes of a very small animal such as an insect are bound to produce a dramatically different perspective from our own, because of the way optics are affected by scale. In theory the vision through an eye with a very small focal length should have immense depth of focus as well as width of field. By stopping down hard on the 'pupil' of this eye, in the same way that one stops down the aperture of a camera, it should be possible to see virtually everything in the visual field in focus at the same time: from microscopic details of the foreground subject to complex features such as trees and mountains on the distant horizon. This is truly global vision, seeing a close-up landscape. I decided to adopt this kind of biological eye as a model for the images I wished to create.

The bulging eye of a fish lends its name to the classic 'fish-eye' lens used in photography to provide extreme perspective and wide angle of view. It is a case of 'like serving like' that these fish have been photographed using the specially-designed panoramic close-up lens.

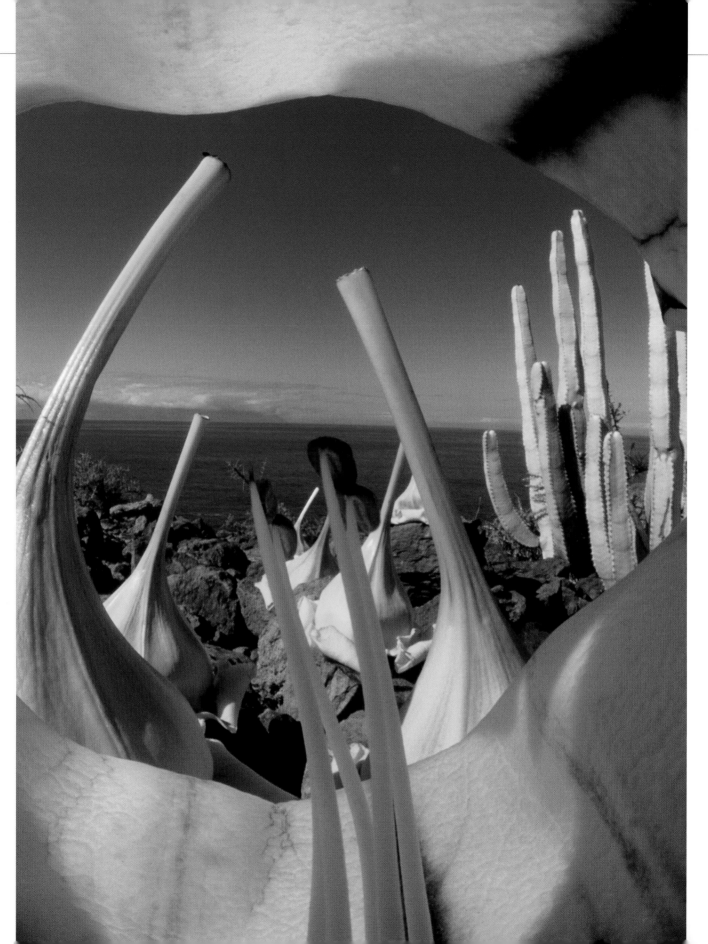

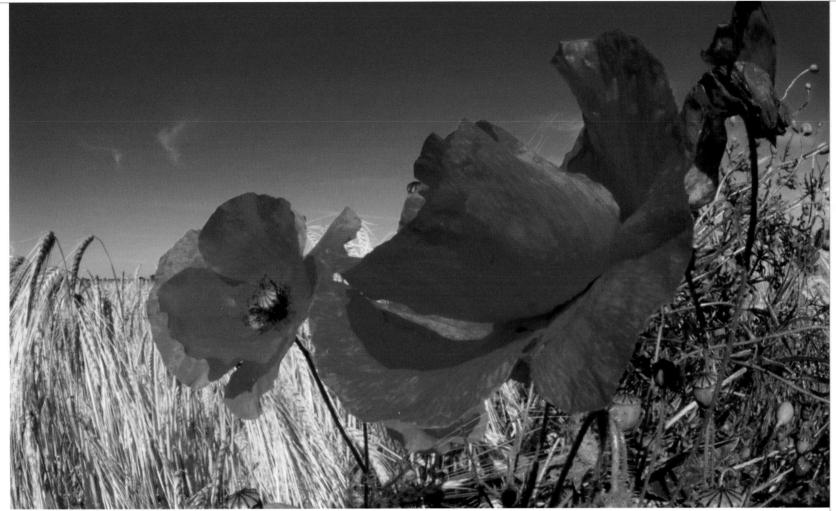

The immediate problem was to translate this idea into workable hardware and after a long trawl through the optical systems on offer in microscopy, video, television and conventional photography, I eventually succeeded in cobbling together a design of my own. Next I began the search for suitable subjects and I soon found that flowers, with their luxuriance of colour and pattern, fitted the bill to perfection. It was also a nice coincidence that they, like my new visual aid, owe their existence to the humble insect.

A bee's eye view of chalice lilies [**01**] and red poppies [**02**]. Like the raindrops, these eyes have a very small focal length, giving global vision in both senses: depth as well as width. Everything is seen in focus at the same time, from microscopic details in the foreground to features on the far horizon. We often think of poppies as swaying in the breeze and indeed insects tend to be attracted by the movement of flowers as well as their colourful appearance and scent. Bees have quite poor red vision and often what really attracts them to red flowers is not their redness but their great sensitivity to ultraviolet light. Red and UV often occur together in flowers; we see one but not the other. On the other hand beetles see red very clearly and are commonly found scrambling inside poppies and other red, cup-shaped flowers.

According to Darwin, the designs that we see in nature are there through a process of natural selection. During the course of evolution the flower experimented with infinite nuances of floral colour and form and arrived at the ones that the insect most frequently selected with its eyes. Few people actively dislike flowers, whilst many are infatuated by them. Precisely why there has been such a stark convergence between the visual sensibilities of insects and human beings is a subject beyond the scope of this book.

A frog's-eye view of yellow water lilies [**01**] and rose-hips [**02**]. It is no coincidence that many berries are red in colour – red is particularly attractive to birds that feed on the berries and thereby help in the dispersal of the plant. The perspective view of this photograph is what we might expect of a small, sharp-eyed bird.

01

02

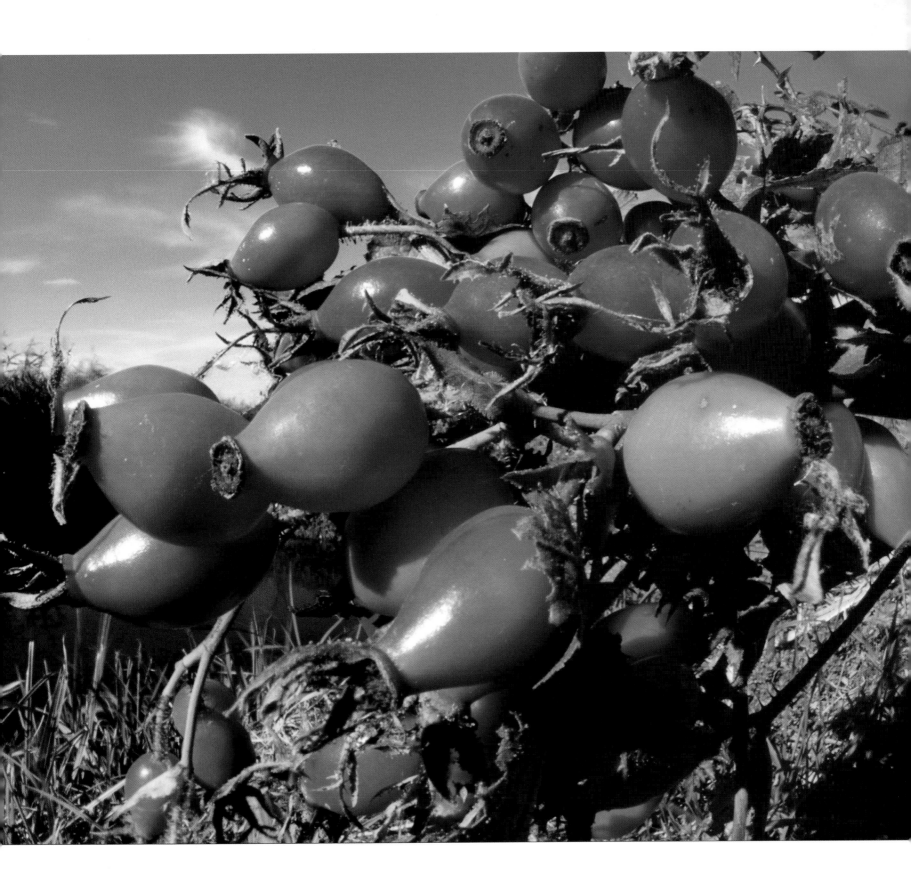

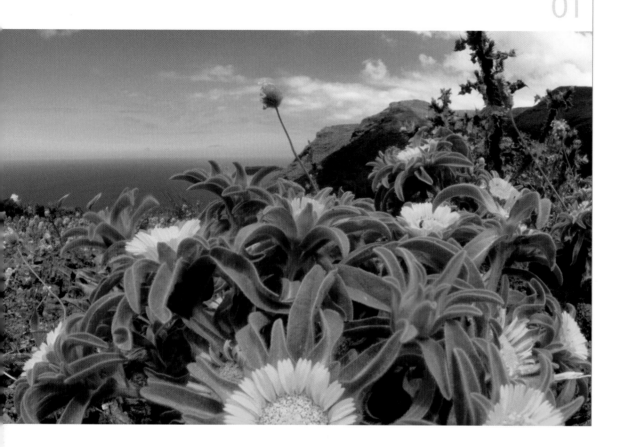

The 'panoramic close-up' images give us an idea of how the landscape would appear to a radically shrunken version of ourselves, a homunculus at home amongst the flowers and grasses. However they do not represent a simulacrum of what a real insect sees, nor are they meant to. Photographers use their cameras as surrogates for their own eyes, and it is an added bonus when the machine transforms the world into something that you could not otherwise experience. We can only imagine what the first microscopists felt when they saw new worlds unfolding beneath their gaze, and the same goes for the pioneering astronomers peering through their telescopes. Sadly, the intimate connection formed between the observer and the outside world when the eye is pressed to a viewfinder is lost in modern compact cameras which supplant reality with a digital screen.

Yellow flowers such as the Asteriscus [**01**] and Lotus flowers [**03**] shown here are attractive to solitary bees which emerge early in the year, and this is the kind of view that an approaching bee might experience, although in far less detail than the photograph shows. Later in the flowering season blue and purple flowers begin to appear and this coincides with the arrival of the larger bumble bees onto the pollen 'market place'. The spidery stems of the wax plant Ceropegia [**02**] are an extreme adaptation to the dry desert-like environment in which it lives. Although It lacks the showiness of many other plants it compensates by having a long flowering season.

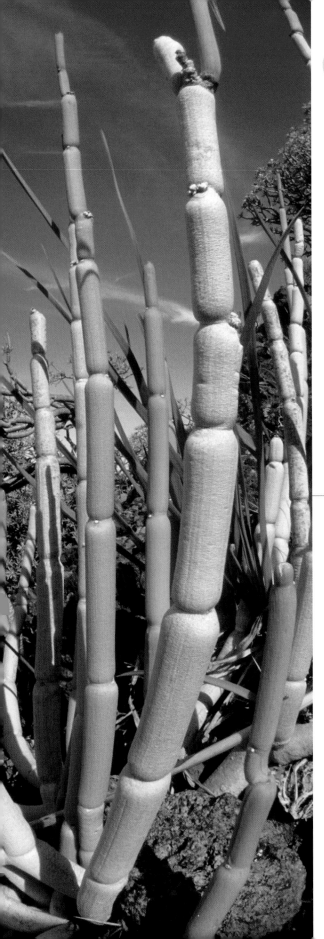

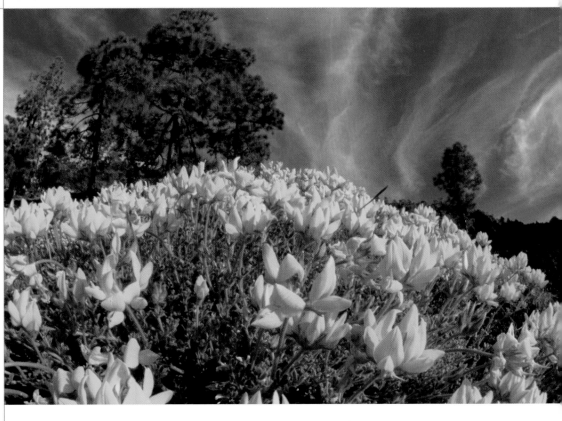

Conventionally our relationship with nature has been that of a spectator viewing from outside; indeed the advent of television and the computer screen has embedded this idea more firmly. Man has strived to capture nature on a two-dimensional interface ever since he began drawing pictures on the walls of caves. It is perhaps a modern challenge to try to reverse the roles: to project our eyes outward onto each pixel of the external world and imagine the view looking back. In a sense that is what I try to do when I position myself at ground level and place my lens within two centimetres of my subject.
I have arrived at these ideas from a practical need to blend photography with sensory perception, but it is familiar territory for philosophers of the Bergson persuasion. Henri Bergson seemed to believe that a two-way contract existed between the human eye and whatever it observed. This is heady stuff which even modern physicists have incorporated into their thinking, but I am content to leave it here as a coincidence.

Views of unopened flower buds of onion plants [01] and from inside a cast snake skin [02]. Once again the perspective and depth of focus are what we might expect of a small animal inside the undergrowth, or indeed a human being shrunk to a corresponding size!

01

02

GLOSSARY

Cavitation: the outcome when an object moves through a liquid so quickly that there is a tendency for the fluid to detach on the downwind side, leaving an area or cavity of negative pressure.

Compressed evolution: we know that biological evolution takes place in a time-frame of millions of years. Compressed evolution means change speeded up, as though things were evolving before our eyes.

Convex and **concave:** terms describing curvature. If a curved surface is raised, such as a rounded hill, it is convex. A sunken curved surface, such as a bowl, is concave.

Corpuscle: blood consists of red and white cells or corpuscles suspended in fluid plasma. The average diameter of a red corpuscle is about one hundredth of a millimetre.

Dynamic pressure: a positive or negative force that results from the movement of fluid, caused by its velocity and its weight. A good example of positive dynamic pressure would be the 'blasting' force created by a high-pressure water jet. On the other hand, the suction of a vacuum cleaner is a negative dynamic pressure, resulting from the high-speed rotation of air inside the cleaner.

Form: often means the same as 'shape', although in this book I use it in the sense where it is often paired with the idea of function or process. So for example, the form assumed by a soap bubble is related to the physical process underlying it – in this case surface tension. This is not far removed from the old Platonic idea that shape or form is a symbolic expression of the inner quality of the subject.

Hydrostatic pressure: the static pressure inside a fluid due to loading from outside. The load might be due to the weight of the fluid itself, as in the pressure of the ocean depths, or it could be the elastic tension in the wall of an inflated balloon.

Laminar flow: engineers recognize two different kinds of flow: smooth, or laminar flow, in which the fluid moves in parallel layers (or 'laminae') that tend to hug the surface over which the fluid passes, and turbulent flow, which breaks down into eddies that detach from the surface. Turbulence usually happens at high speeds and imposes an extra drag on the surface that might be, for example, an aircraft wing.

Lens: a regularly curved surface which will bend light away from its initial path, either as it passes through the surface (refraction) or as it is reflected from it (reflecting or mirror lens). As a result, all the light rays from each point in the field of view of the lens converge to a single point in the image formed by the lens. The complete image consists of all these focused points.

Pinocytosis: the process whereby the surface of a cell engulfs a particle and passes it to the interior. The particle is locked inside a pod or vesicle of membrane, which is emptied into the cell along with the particle.

Polymers: materials made of long, string-like molecules with side branches that stick to one another. When a polymer is stretched the molecules are also stretched and 'ratcheted' along their side branches: this gives the material elasticity and tensile strength.

Surface tension: the tendency of the surface of a liquid in contact with the air to contract spontaneously. It is a result of the inwardly directed forces of the outer layer of molecules. Were it not for gravity, any volume of water would tend to contract into the shape of a sphere. The elastic surface film can attract things which are 'wettable', such as glass, or repel things which are water resistant, such as wax. Some insects can support themselves on the water surface by using waxy feet.

Viscosity: a measure of the 'stickiness' of a liquid due to the mutual adhesion between the molecules of the liquid itself and any surface which it comes into contact with. The latter is the source of viscous drag felt when drawing a rod through treacle or walking through a muddy field.

Vortex: an example of circular flow, such as whirlpools, whirlwinds, typhoons and vacuum cleaners. They usually have an extremely low pressure at their core.

ACKNOWLEDGMENTS

I would like to thank the following for technical help and advice in various aspects of photography: the Photographic and Illustration Service of the University of Cambridge, and in particular Roy Barlow; the Audio Visual Media Group of the PDN Department of the University of Cambridge; Dr Davor Dukic of the University Engineering Department; Mr Michael Barker of Eagle Electronics, Yorkshire. The various photographic clubs and societies at which I have lectured have provided invaluable feedback and, though too numerous to mention individually, I thank them all. Creating a book is a team effort involving far more people than the author himself, and in particular I would like to thank Neil Baber the Commissioning Editor and Emily Pitcher my Editor for their constant support, encouragement and professionalism.